VISIONS OF

BRITISH

A Landscape Manual

COLUMBIA

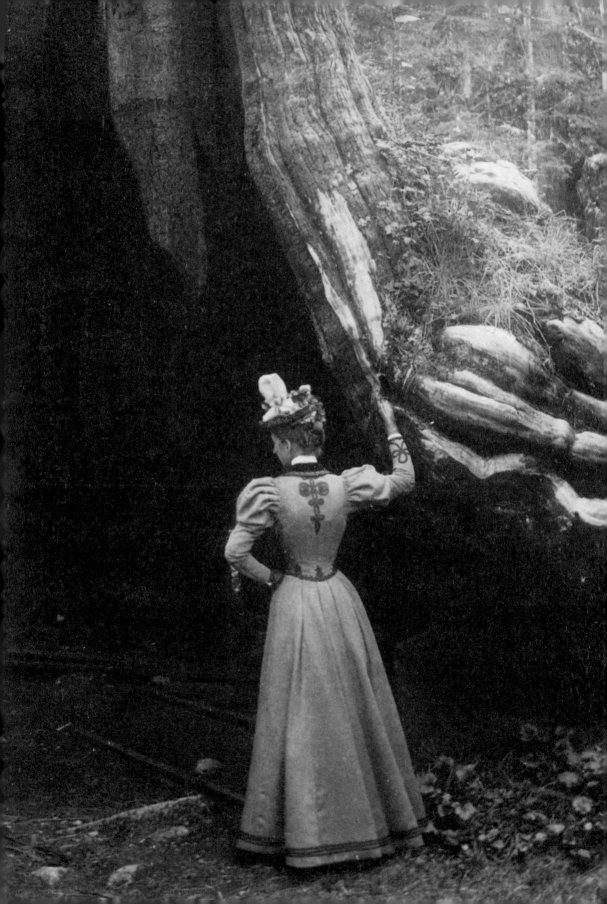

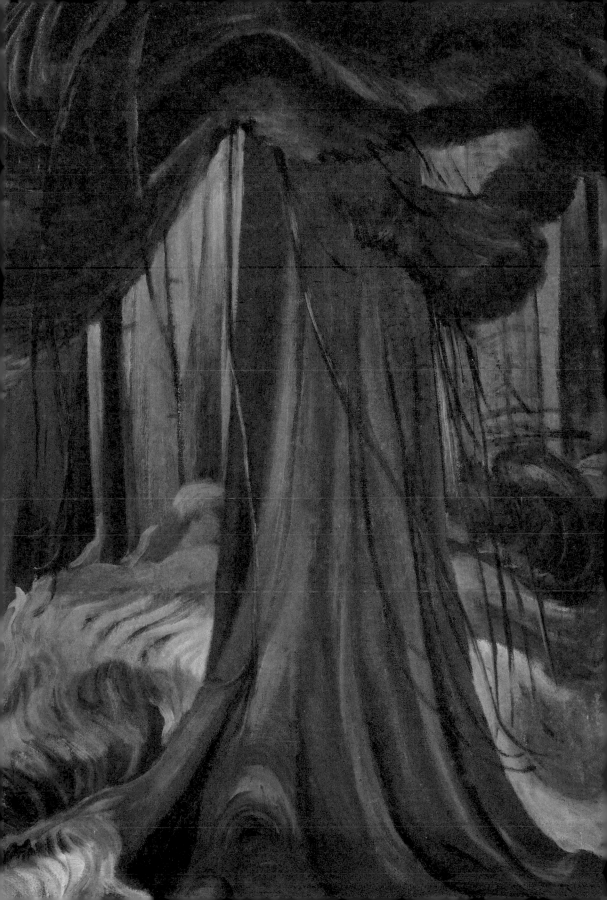

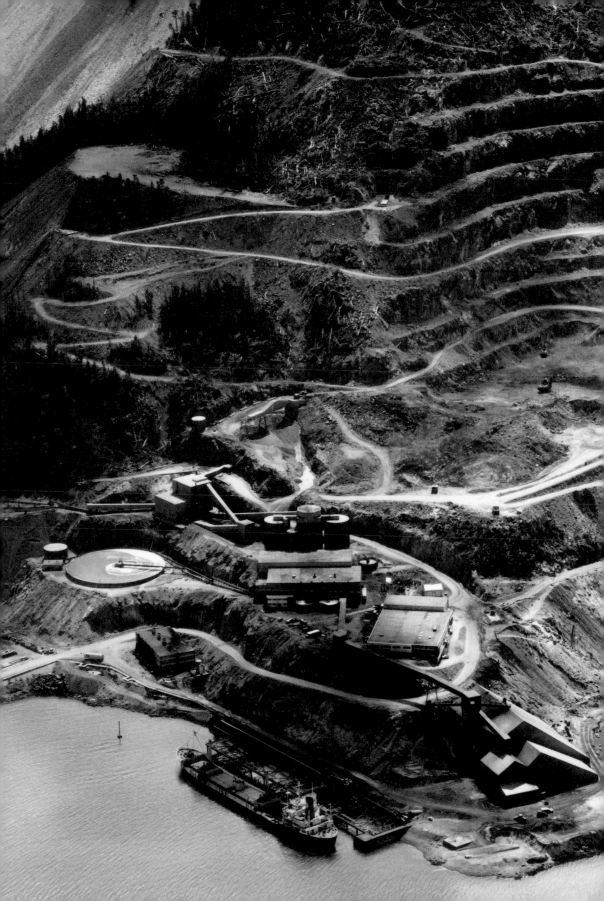

Isla de S. Chris
tina.

pta
de S. maria
magdalena.

P. de S. marga
ritas

Pun de S. Np.

Brazo de mar Internado p. el Este, sin
do Reconocerlo la cauza dela mucha Corrie

Cerros a

Surgidero de
S. Lorenzo 26

P. ta de S. Estevan.

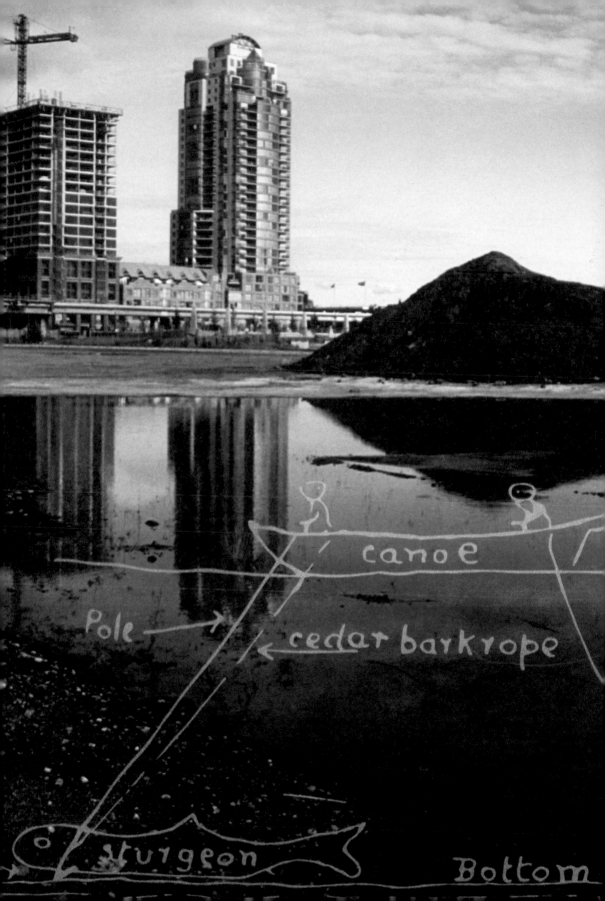

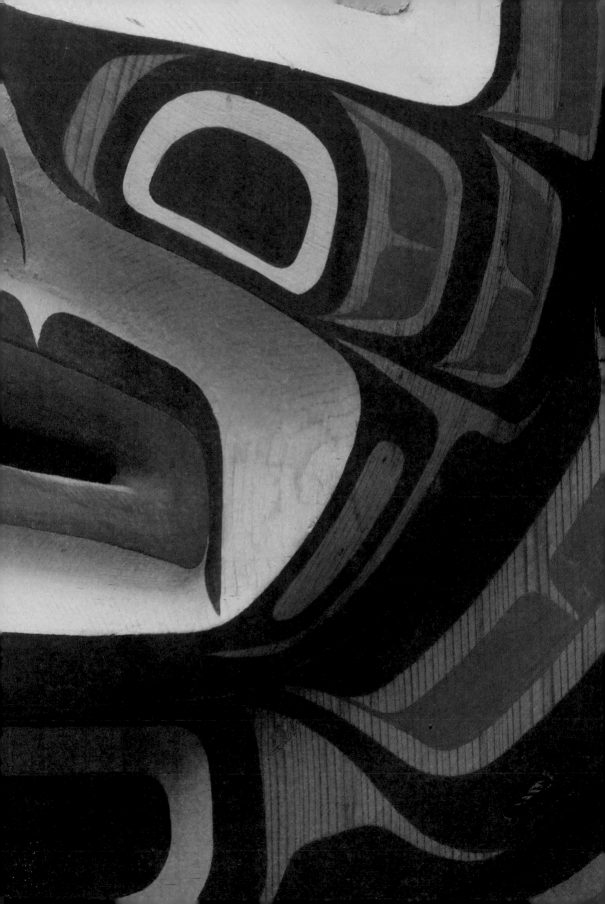

edited by **Bruce Grenville** & **Scott Steedman**

VISIONS OF

BRITISH
COLUMBIA

A Landscape Manual

Vancouver Art Gallery
Vancouver

Douglas & McIntyre
D&M PUBLISHERS INC.
Vancouver/Toronto/Berkeley

Contents

facing: **Ingrid Baxter and Iain Baxter** |
Bagged Landscape, 1966 (detail)

facing: **Stan Douglas** | Russian Orthodox Church at Stamps Place (Strathcona series), 1998 (detail)

provided by supporting sponsor, Vancouver Airport Authority, and the Vancouver Foundation, to whom I am also very grateful. I also acknowledge the Gallery's Board of Trustees, led by David Aisenstat, for their guidance and unwavering commitment to providing the highest level of programming.

Finally, I extend my deepest appreciation to the artists in the exhibition, whose work has been critical in defining an understanding of this place and is an important legacy for the people of British Columbia.

KATHLEEN S. BARTELS
Director, Vancouver Art Gallery

Jeff Wall and Robert Davidson, have been instrumental in defining our understanding of British Columbia and its inhabitants. Along with historical and modern figures such as Emily Carr, Fred Varley, Bill Reid, E.J. Hughes, Gordon Smith and Gathie Falk, the many artists here have shaped a collective consciousness of this province. The publication pairs the works of thirty-seven seminal artists with texts by British Columbia writers who explore similar themes and narratives that open up interpretations of these artworks.

The subtitle of the exhibition refers to Jeff Wall's *Landscape Manual*, a booklet Wall self-published in 1970, in which the artist provided commentary on the making of landscape photographs. It was one of the starting points for a radical art practice that would change the face of contemporary photography forever and coincidentally would bring an international awareness of the urban and suburban landscapes of Canada's West Coast. This volume and the exhibition are also intended to act as a type of guide for those who wish to consider the fundamental role of art and literature in building and sustaining a public awareness of British Columbia and the peoples and histories that have shaped it.

I commend Bruce Grenville, senior curator, for his thoughtful and insightful development of the exhibition and this publication. Special thanks to the extraordinary staff of the Vancouver Art Gallery for their dedication to all aspects of this project. I am also very grateful to the generous lenders to the exhibition who supplemented the Gallery's holdings with works from their private collections. I would like to acknowledge and thank Scott McIntyre and Chris Labonté of Douglas & McIntyre, our co-publisher, whose commitment to the art and literature of this region is embodied here. The book's structure was inspired by conversations with Scott Steedman, our co-editor, about a publication that would bring together artists and writers, and we are grateful for his thoughtful selection of texts.

This remarkable exhibition would not have been possible without the generosity of our presenting sponsor, Raymond James Ltd., and major support from the Province of British Columbia, and I offer my sincerest thanks for their financial contributions. Additional financial support was

Foreword

The exhibition *Visions of British Columbia: A Landscape Manual* offers an
important opportunity to delve into the Gallery's permanent collection
and to present interpretations of British Columbia as seen through
the eyes of its most important artists. The selection of historical and
contemporary works includes landscapes, cityscapes and portraits in
a variety of media that speak to the diverse visions of this place, its
peoples and its histories—a unique perspective, especially relevant
when the eyes of the world are on Vancouver for the 2010 Olympic and
Paralympic Winter Games.

Vancouver is widely recognized as an international centre of con-
temporary art production, and many of the region's most pre-eminent
contemporary artists, including Stan Douglas, Rodney Graham,

facing: **Emily Carr** | Strangled by Growth, 1931 (detail)

The Art

Visions of British Columbia: A Landscape Manual has a simple but fundamental purpose: to provide an introduction to this province through the eyes of its artists. From the earliest days to the present, artists have played a critical role in recording, communicating and shaping the public perception of British Columbia. Through their art we have come to understand the extraordinary diversity of this region and its many peoples and places.

The works presented in the exhibition and in this book are drawn primarily from the collection of the Vancouver Art Gallery. For more than seventy-five years the Gallery has collected the art of Canada's West Coast. Drawing upon the collection we could easily have built many different visions. The configuration we have chosen is offered as a chronological narrative, starting with the art of Charles Edenshaw, a Haida artist of renown whose carvings have influenced artists throughout the region,

facing: **Jeff Wall** | River Road, 1994 (detail)

and continuing through to the many internationally acclaimed artists of the present day. In total, the works of thirty-seven artists are highlighted in the exhibition. Each artist is represented by a small group of outstanding works or a major installation, many of them canonical works within the collection and the history of this province.

We chose also to produce this companion volume, which would allow us to closely link the visual art of British Columbia to its literature. In part this project acknowledges the long-standing and fruitful connections between artists and writers here, but it also allowed us to bring many more voices to the table, expanding the vision. Instead of the usual catalogue copy, which draws us deeper into the artwork but closes out the world beyond, co-editor Scott Steedman and Gallery staff have chosen writing that exists in its own right as whole and meaningful text, while simultaneously offering a new insight into the shared subject of both the literature and the art.

Employing a wide range of media and narrative strategies, these artists offer visions that have deeply affected people who encounter them. For most of the artists a "vision" is both a mode of perception and a mode of conception, which is to say a manner of apprehending the world around us and at the same time a means of producing that world. To varying degrees and in diverse ways they declare that it isn't enough to simply observe the world, to call it to our attention, to name it or to transcribe it. They challenge art to give shape to the world, to generate visions so compelling that we perceive the world in ways that give it new purpose and meaning.

Among the earliest works in *Visions of British Columbia* are the sculptures produced by anonymous artists of the First Nations, artists who played a fundamental role in articulating the history of the first peoples who inhabited this place, and who continue to shape and define the public perceptions of the land. More recently, artists whose names are now widely known remind us of our continuing connection to the places and creatures that determine our social, political and familial relations.

Emily Carr's paintings of the forest done in the 1930s describe a world that is dark, mysterious and impenetrable and yet entirely vulnerable to the economic forces that can reduce a forest to stumps, leaving only a few spindly trees that aren't even viable enough to harvest. A little more than

fifty years later Jeff Wall photographed a monumental lone pine tree on a corner lot in a Vancouver suburb. Like Emily Carr's scorned timber, this tree signified the presence of a transformed landscape, but it stood as a last sign of nature in an otherwise defeatured (and denatured) landscape. Ian Wallace, in his series of paintings documenting the Clayoquot protest of 1993, looked once again to the denatured forest as a sign of the economic and political forces at play. In the largest act of civil disobedience in this province, citizens blockaded the logging roads of Clayoquot Sound, and Wallace challenged his viewers to reconsider their role within a pervasive system that allowed for the destruction of old-growth forests.

Significantly, both Wall and Wallace also invited their viewers to consider the long and often problematic role of art in the documentation of social history and the construction of the heroic figure—whether it is a person or a tree. They recognize the persuasive authority of history painting, referenced specifically in the scale and, in the case of Wallace, the medium of their work. Jin-me Yoon's 1996 photo installation A Group of Sixty-seven likewise addresses notions of the heroic figure and the symbolic landscape of this region. Placed against the backdrop of a Lawren Harris mountain painting and an Emily Carr forest painting, sixty-seven Korean-Canadian immigrants bear witness to their difference and to the persuasive language of modernist landscape painting that has come to stand for a Canadian identity. Who are these heroic figures against this landscape? What place did they have in this picture? And who are they once we recognize them in that location? In these ways Yoon invites us to consider the fundamental role of art in shaping and defining our perception of the landscape and the place we occupy within it.

With determination, pathos, humour, anger, frankness, frustration and awe, these artists have studied the people and places of British Columbia and offered visions that, when gathered together, can offer a guide or a manual for negotiating this region. The subtitle for the exhibition, A Landscape Manual, is lifted from a photo/text bookwork by Jeff Wall, produced in 1970. In a manner typical of the period, this bookwork is both a meditation on the production of photo-based images and a parody of the process-based narratives of conceptual art. In a way, this exhibition was conceived in the same spirit. On the one hand we have proposed with great hubris that Visions

of British Columbia offers a comprehensive introduction to the West Coast and a meaningful guide to it through the art of its people, but on the other we acknowledge that any vision is also an apparition, an image conjured up in response to our desires, hopes and dreams for the place in which we live.

The thirty-seven artists highlighted in this exhibition could be said to represent the wide variety of concepts, purposes and cultural origins of the art and artists of British Columbia. But even as this proposition is made it seems necessary to qualify and supplement it, and so within the exhibition an introductory narrative has been conceived in the form of a *Wunderkabinett*, a cabinet of wonders composed of diverse images and objects drawn from the broadest possible range of visual culture, offering yet another kind of vision of the province, its peoples and its histories. Here, an image of the first known map of the coastline, drawn by Jose Canizares in 1775, sits in considered proximity to an argillite plate carved by the legendary Charles Edenshaw. Both works describe a world of wonders, fantastic landmarks and legendary creatures that give meaning to this place, shaping our understanding and defining our relations. Mattie Gunterman, a pioneering photographer of the late 1800s, offers a rare glimpse into the lives of immigrant women in a forbidding landscape, while Ken Lum's photo-based image *Melly Shum Hates Her Job*, from 1990, suggests a very different, but equally challenging, immigrant experience.

Within the space of the *Wunderkabinett* we are reminded of the breadth and complexity of the visual culture of this province, and the necessity to start any discussion of its histories from a location that gives us a broad and meaningful vantage point. From here we are invited to move toward a vision of British Columbia that is informed by a wealth of interconnected and interdependent narratives, concepts and modes of production. The vision is as varied as the artists who have produced it, and as diverse as the landscape that inspires it. From the ocean to the mountains, rivers, forests, beaches, deltas, streets, lawns and sidewalks, this place provides a seemingly endless impetus to artmaking.

BRUCE GRENVILLE
Senior Curator, Vancouver Art Gallery

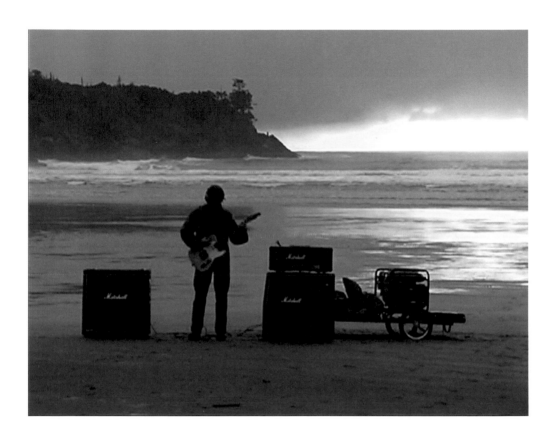

Kevin Schmidt | Long Beach Led Zep, 2002 (still)

The Literature

New Caledonia, Gold Mountain, the Rain Coast, Lotus Land, the Best

Place on Earth: British Columbia has had many nicknames, some rich in

promise, others fraught with skepticism. But all its residents, newcomers

and old-timers, agree that it is a world apart, a verdant paradise between

the mountains and the sea that has never been part of the mainstream.

Captain George Vancouver, who charted the coastline for the British

Royal Navy in the 1790s, called it "a most lovely country" and then named

one inlet Desolation Sound because of the effect it had on him; to the

writer George Woodcock, it was a land of "ravens and prophets." What is

the particular genius of this place, home to some of the most extra-

ordinary aboriginal culture on the planet, and still a magnet for dreamers

and immigrants, castaways come to remake their lives far from the

hidebound Old World?

facing: **Jin-me Yoon** | Fugitive (Unbidden #3), 2004 (detail)

Arriving in Vancouver by plane from the east, visitors are immediately struck by how precarious man's hold is upon the unbridled wildness all around. Jagged rock tilts vertiginously into sea; the green valley may stretch all the way to a town called Hope some hundred kilometres to the east, but on three sides the lush delta is fenced in by dark green walls of cedar and hemlock, impenetrable forests that none but a few hikers know. And Vancouver is the last city of note on the coast; to the north lies 2,700 kilometres of byzantine coastline, still the domain of the grizzly and the wolverine, a dark primordial land that has almost nothing to do with most of us. While we eat sushi and talk real estate and Hollywood gossip, the densely forested peaks to the north of Vancouver are just a pretty backdrop. Most Vancouverites (and three-quarters of the province's residents live in the Lower Mainland) know more about Los Angeles, New York, Beijing or Manila than they do about Kamloops or Kitimat, let alone working a trapline in the Peace Country.

My brother-in-law spent two years in those forests, his first job after five years on campus. One afternoon he and five other junior foresters—skinny kids straight out of college, snowboarders and punk rockers—were stalked by a cougar. It came at them silent and determined, a mighty predator going about its business. For an hour and a half, the longest of their lives, they backed off. And every time they thought they had shaken it off, an otherworldly snarl would rip through the air and there it was again, crouched on a log in a clearing, tail flicking. "It was pretty scary to realize we weren't top of the food chain," he said the next day. "We were prey animals, being stalked by a two-hundred-pound carnivore. In her home turf!" By nightfall he was back at his condo above a latte joint in Kitsilano.

Reading dozens of books written in and about the province, one is struck by how few "celebrations" of the place one comes across. Where are the literary equivalents of the "Best Place on Earth" licence plates that have sprung up for the Olympics? In their stead are a multitude of polemics, ballads, dirges and cries of protest. How alone so many of these writers sound, cast adrift on a wild coast, cut off and despairing of mainstream life and struggling to make sense of what they have found instead, be it a cabin on a rainy island or a rundown "heritage home" off Kingsway.

That said, for a young province, British Columbia has produced a lot of fine writing. For over a century, something about the place has attracted creative people, drawn to a green, unformed world rich with possibilities. Until recently, most of the best writers—Ethel Wilson, Malcolm Lowry, Dorothy Livesay, George Woodcock—were educated elsewhere. English-born Lowry lived in a squatter's shack on the tidal flats at Dollarton in Vancouver Harbour while struggling to complete his masterpiece, *Under the Volcano*. The shack looked out on one of those floating service stations that cater to boats and float planes; the first letter in the red neon sign was broken, and Lowry loved to sit there at night with the word HELL flashing at him across the inlet. Poor, uprooted, alcoholic, living off the grid: the quintessential B.C. author. And yet much of his writing, including the two selections you'll find here, is luminous, ecstatic stuff.

Then came the sixties and an extraordinary burst of homegrown creativity; in many ways we are still in its long tail. The best writers were poets, and many are sampled here: bill bissett, Fred Wah, Daphne Marlatt, Roy Kiyooka, as well as the new generation, writers like Clint Burnham and Rita Wong. And still they come: Ronald Wright, a fine novelist and travel writer as well as one of the new century's great political writers, was born in England but settled on Salt Spring Island a few years ago, in a solar-powered house with a well and a vegetable garden. His two most recent books, *A Short History of Progress* and *What Is America?*, are elegant but scathing critiques of capitalism, and both were worldwide bestsellers.

The texts in this book are a very slim sampling of all the fine writing produced in and about British Columbia. Choosing what to include was a near impossible task. There is a lot of poetry, because poetry is so precise; Joe Ferone's "BC Collateral" conjures up a place and a feeling in four lines, a minor miracle. Good novels or long works of non-fiction can do this a thousand times over, but they tend to take their time in the telling. This makes excerpting them a frustrating business, especially when the agreed-upon maximum length is eight hundred words. This constraint meant that much excellent writing just didn't qualify. Reading, for instance, Eden Robinson's wonderful first novel, *Monkey Beach*, set in and around the Haisla community on the central coast, I found myself cursing her for creating such

a broad and convincing world. To select one page and reproduce it out of context would have been folly, so we haven't.

A final word about the connections between the pictures and the words. When we started this project, Bruce Grenville asked me to find texts that commented on or complemented the art he had chosen for the show. The first examples I found did so literally and seemed too laboured. We were much more excited by texts that explored similar themes to the art, even if these were written decades apart or the link seemed tangential. Hence you will find an excerpt from Charlotte Gill's hilarious 2007 piece on tree planting, "Eating Dirt," next to a 1935 Emily Carr painting of a logged landscape, and a Douglas Coupland description of a beached whale alongside Brian Jungen's sculpture *Cetology*. I hope the threads linking the two are clear, even if artist and writer seem like fish and fowl at first glance.

British Columbia is an incredibly varied place, both in its land, which runs from rainforest to grassland to taiga to bona fide desert, and in its people, who come from more than thirty aboriginal language groups and hundreds of faraway shores, and regard it with as many world views. A Japanese fisherman sees one thing when he looks upon a wild wooded fjord, while a Finnish minister seeking Utopia, a Tlingit basket weaver or an Anglo-Saxon salmon farmer sees quite a different reality. Making sense of this kaleidoscope of visions is no easy matter for the art curator or anthologist, let alone the politician or nation builder. I hope this book, with its many overlapping points of view, conjures up some of the most potent of these myriad visions of British Columbia, as seen by its best visual and literary artists.

SCOTT STEEDMAN
Editor

facing: **Michael Nicoll Yahgulanaas** | Looking Out #11, 2006 (detail)

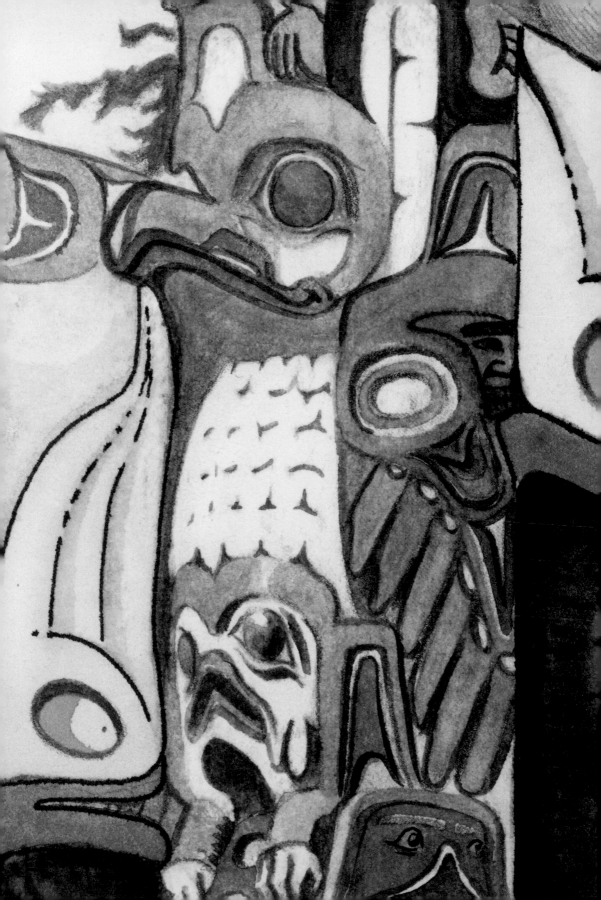

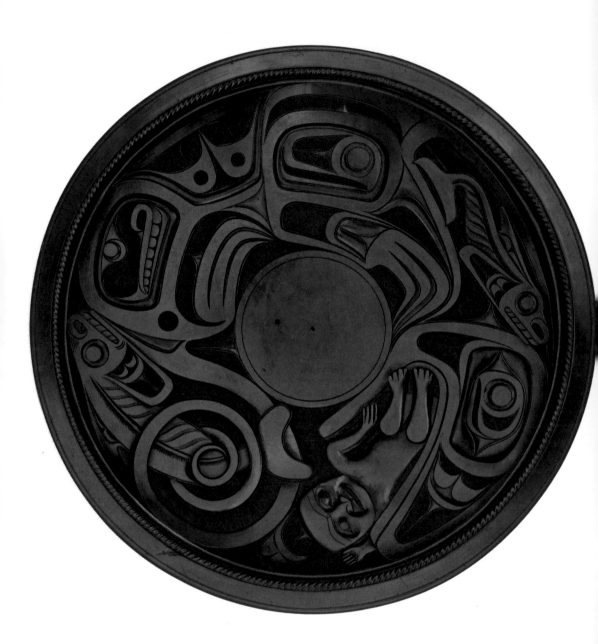

ARTIST **Charles Edenshaw**

AUTHORS Leslie Drew &
Douglas Wilson

facing: **Charles Edenshaw** | **Plate**, late 19th century

Leslie Drew & Douglas Wilson | Argillite (excerpt)

We shall now concentrate on a single spot on southern Graham Island—
a narrow, uninhabited valley with a creek that tumbles into Skidegate Inlet.
This is the Slatechuck, the mysterious source of the Haida carvers' slate
called argillite. There, on a steep slope, lies the deposit which has been a
King Solomon's mine for the Haida. From this lode they developed their art
of argillite carving, which is as unique as the substance itself...

It is a semi-secret place, visited only by Haida carvers who quarry this
slate that they alone know how to select...

It is a sunny day in late September. Seven young men have set off in the
early morning from Skidegate, pointing their fiberglass-hulled motorboat
in the direction of Slatechuck Mountain, rising high above inlet waters. The
boat glides noisily past islets, startling a flock of cormorants perched like
black watchmen on a nearby rock. Had this boat been a canoe, such as the
men's forefathers once used, the birds would scarcely have turned their
craggy heads. In no time at all, it seems, the boat eases into a green-water
cove rimmed with spruce trees. This is Kagan Bay, the jumping-off point for
the onerous trek to the quarry itself.

The men—two brothers who both carve argillite and five of their
nephews—haul the boat up the beach beyond high-tide mark. They remove
their packboards, now containing only their lunches, and strap them on
their backs. By the time they return here, these packboards will be loaded
with 500 pounds of argillite, a year's supply for one of the brothers,
who lives on the mainland. The men are lightly clad and wear knee-high
rubber boots.

There is no one else for miles around, and the stillness of the Slatechuck is almost overwhelming, even to people accustomed to silence. They start hiking into the bush at a slow, even pace, reserving their strength for the hard climb ahead. For a while, the trail follows the Slatechuck River... Soon the men plunge into dense rain forest, climbing steeply over ground riddled with fallen logs, spruce roots, mudholes, boulders covered with moss a foot thick. They stop every so often to catch their breath, then struggle on.

After nearly an hour, they reach the floor of the Slatechuck Valley. The region was logged at one time, and still shows the signs of stumps notched for springboards. The men pause briefly, amid the dense new growth which has sprung up after the logging. Anyone unfamiliar with this wild terrain could easily become lost here, deep in the mountains, but these men know exactly where they are going, and now they brace themselves for the final ascent.

One by one, keeping out of each other's way to avoid being hit by falling rocks, they climb almost straight up for 100 metres, clambering hand-over-hand for the last stretch. Hot and tired, they finally reach the "mine."

It is simply an 80-degree, pockmarked slope with overhangs and ledges... Pitched at this steep slant, the argillite source does not even resemble a quarry. It is certainly the cleanest mine in British Columbia, and one of the oldest. That so much beauty could come from such an unspectacular hand-dug perch on a mountain seems almost impossible...

The past is ever present on this secluded route. The scene is one of eternal peace and changelessness. Mossy boulders. Licorice fern. Dark glades illuminated by shafts of sunlight. Pungent rain forest scents. Nothing has altered since argillite packing began; when the old ones came by canoe, trundled up the trail barefoot, hacked out the slate with simple wedges, and toted it out in woven cedar-bark slings. The process is supremely basic. All it takes is hard human effort. But then the burden is always lightened by the thought—the vision—of the beauty that will emerge when the raw slate undergoes transformation.

—1980

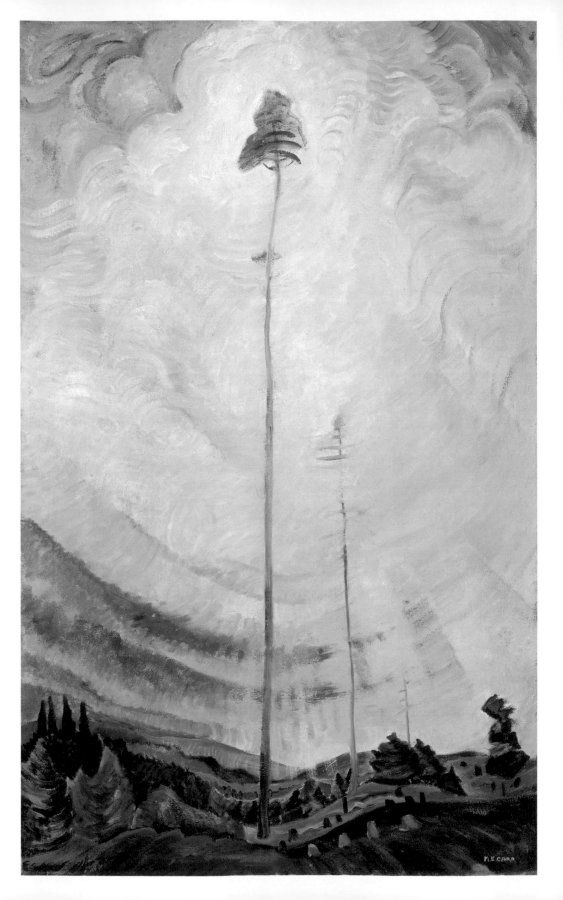

ARTIST **Emily Carr**

AUTHOR Charlotte Gill

facing: **Emily Carr** | Scorned as
Timber, Beloved of the Sky, 1935

Charlotte Gill | Eating Dirt (excerpt)

We tumble out from pickup trucks like clothes from a dryer. Earth-stained on the thighs, the shoulders, around the waists with muddy bands, like grunge rings on the sides of a bathtub. *Permadirt*, we call it. Disposable clothes, too dirty even for the laundry.

Just two hours ago we fell out of bed and into our rags, still crusted with the grime of yesterday. Now here we are, spilling from one day into another, as if by accident, with unbrushed hair, stubbled faces, sleep still encrusted in the corners of our eyes. We drink coffee from old spaghetti sauce jars, gnaw at protein bars dressed in foil. Cigarettes are lit before feet hit the ground, and the smoke drifts up in a communal cloud.

We tighten the laces of our tall, spike-soled boots, strap on soccer shin pads. We dig through rubber backpacks for Marigold gloves and duct tape and knee braces made out of hinged aluminum and Neoprene. We tug it all out in preparation for a kind of battle. We're proud, and yet ashamed.

There is something bovine about us, our crew. We let ourselves be steered this way and that by the barks of our supervisors. At the same time we hate to be told what to do. We slide waxed boxes from the backs of the trucks and fling them down at the road. *Handle With Care*, the boxes read. *Forests for the Future*. Nothing about this phrase is a lie, but neither is it true.

Young planted forest dots the valley the way hair grows in after a transplant. Loggers crawl the mountains. Their trucks climb in the distance, like white bars of soap carried by ants. Trucks going up, trucks going down. The tidal motions of bush work, up to the peaks in the morning, down to the mainlines in the evenings. Logging roads cross-cut the landscape like old

surgical scars. Few residents but plenty of business. Every crag and knoll cruised, engineered, divvied, high-graded, surveyed from the air. *Creamed,* as we are fond of saying.

"Damn cold," we mutter, rubbing our palms together. We're in shadow, and the air has the stale, uncirculated feel of a cold-storage room. A preserved chill. There is nowhere to hide from it. No inside to duck into for warmth. Ancient forest surrounds us at the far edges of the clearing. Wind-beaten underdog trees with flattened bonsai crowns. Douglas fir with the tops blown off. Gnarled cedars with bleached wood tusks protrude from lofty, lime-green foliage. Trees with mileage, like big old whales with harpoons stuck in their flanks.

A buzz develops all at once and out of nothing at all, the way bees begin to vibrate when they're about to flee the hive. A box of seedlings is ripped open. A paper bag torn. Bundles of plastic-wrapped seedlings jumble out. The stems are as long as a forearm, the roots grown in Styrofoam tubules to fit in the palms of our hands. We like this thought, it lends a kind of clout— trees grown to our ergonomic specifications.

Boot spikes crunch around in the gravel. A runaway seedling rolls down the road. We jostle around one another, hungry for the day that awaits us. We throw down our treeplanting bags and kneel down next to them and cram them with trees. We do it with practiced slapdash, as cashiers drop groceries into white plastic bags. We bump shoulders, quick-fingered and competitive, like grannies at a bargain bin.

Treeplanters—one word instead of two. Little trees plus human beings, two nouns that don't seem to want to come apart.

—2007

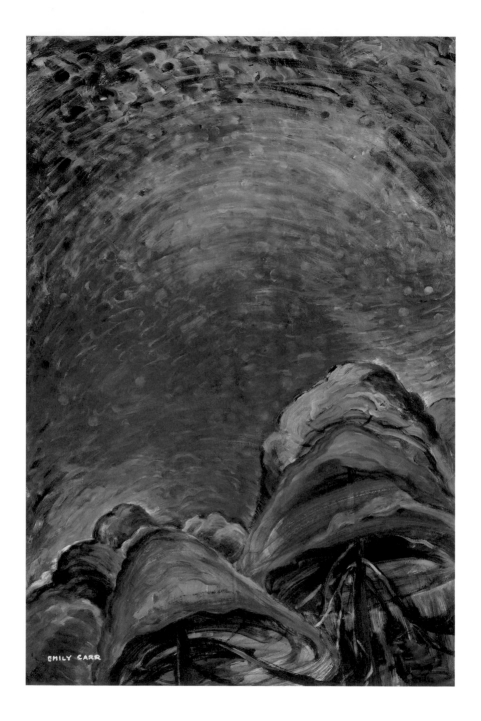

Emily Carr | Above the Trees, c. 1939

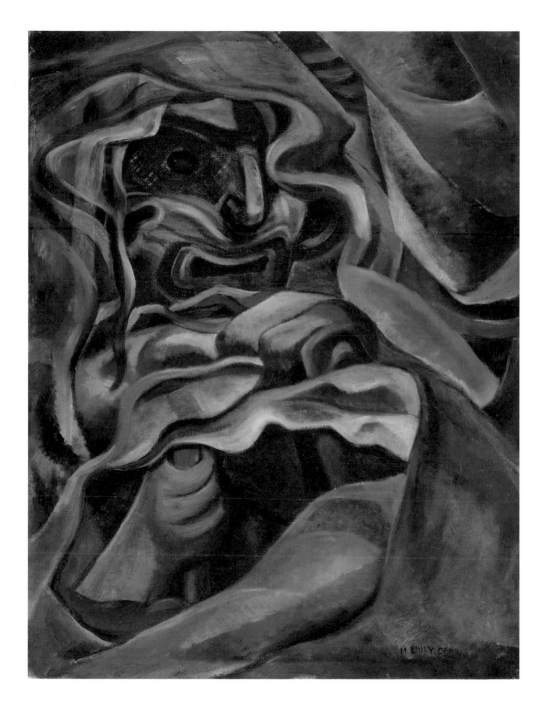

Emily Carr | Strangled by Growth, 1931
overleaf: Emily Carr | Above the Gravel Pit, 1937

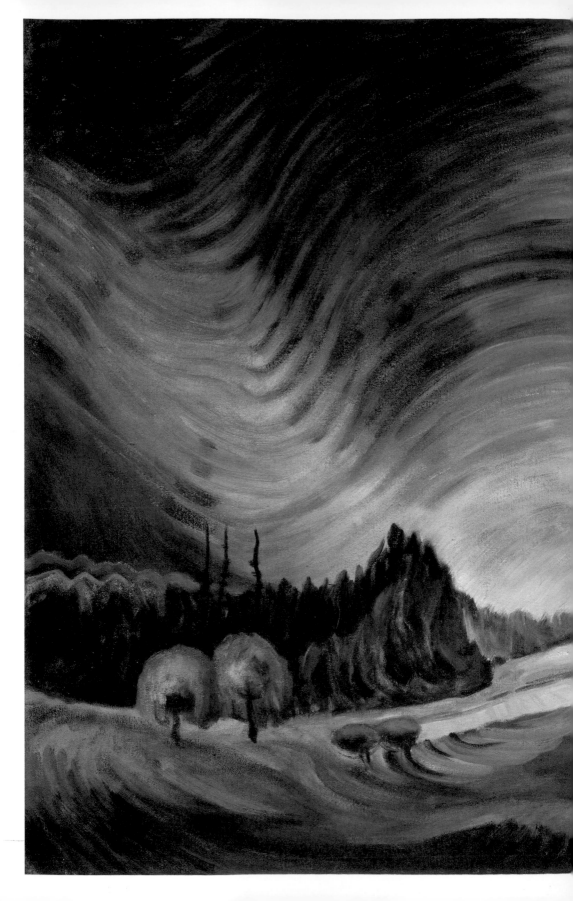

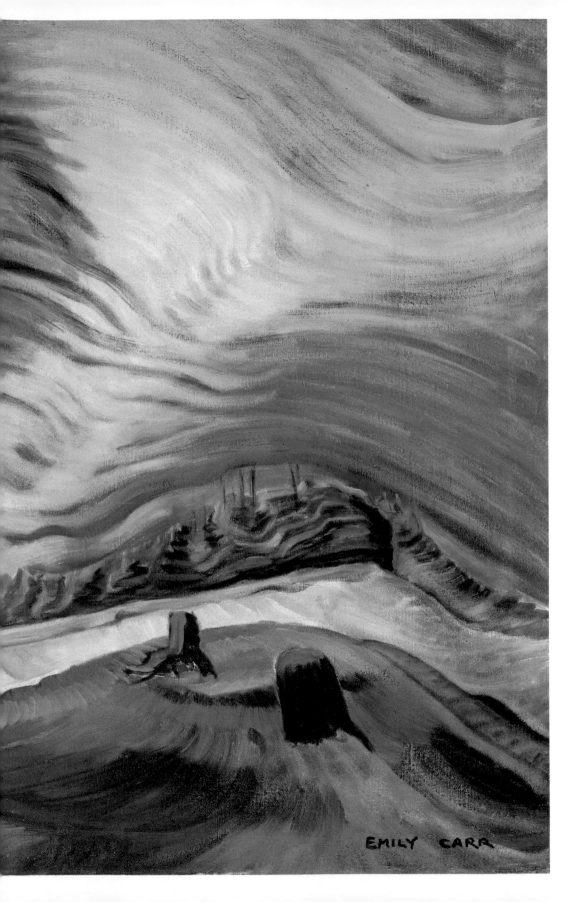

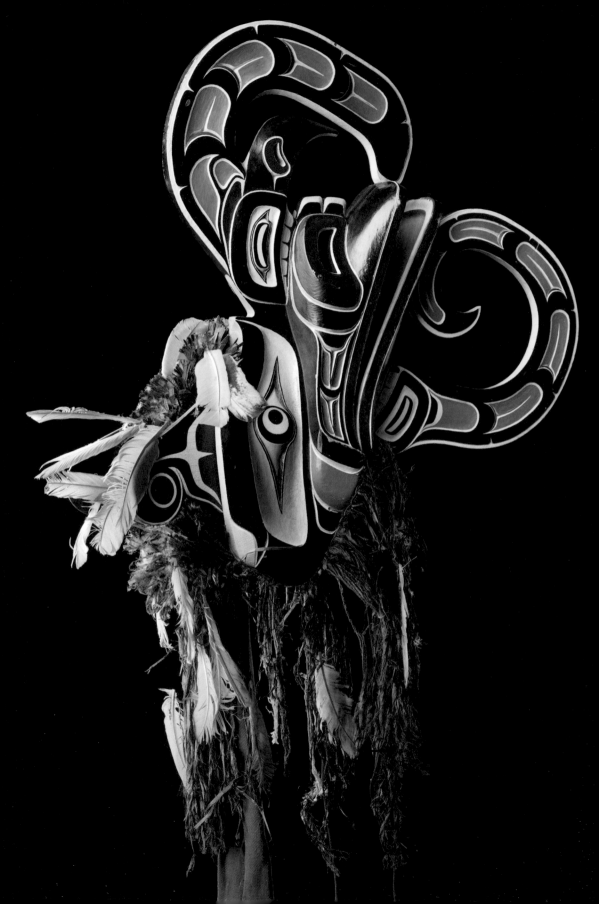

ARTIST **Willie Seaweed**

SOURCE Kwakwaka'wakw tradition

facing: **Willie Seaweed** | Mask, c. 1940

The Birds of Heaven

I will talk about the middle between our
world and the upper side of what is seen by us, the blue sky where
the sun and moon and the stars stay, that is what I
mean, the names of the various birds of the Rivers Inlet tribe, the
 Crooked-Beak-of-Heaven and the Hōx̣ʷhōkʷ-of-Heaven and the
Raven-of-Heaven and the Screecher-of-Heaven and the Oogwaʹxtâᵋyē, and
many others whose names I do not know, the various birds
above the clouds. The Rivers Inlet people just say
that they are all the time flying about, these large birds above the clouds,
 for they have no country in which to stay to
take a rest.

—*Kwakwaka'wakw tradition, transcribed by Franz Boas, 1930*

facing: **Willie Seaweed** | Mask, c. 1926

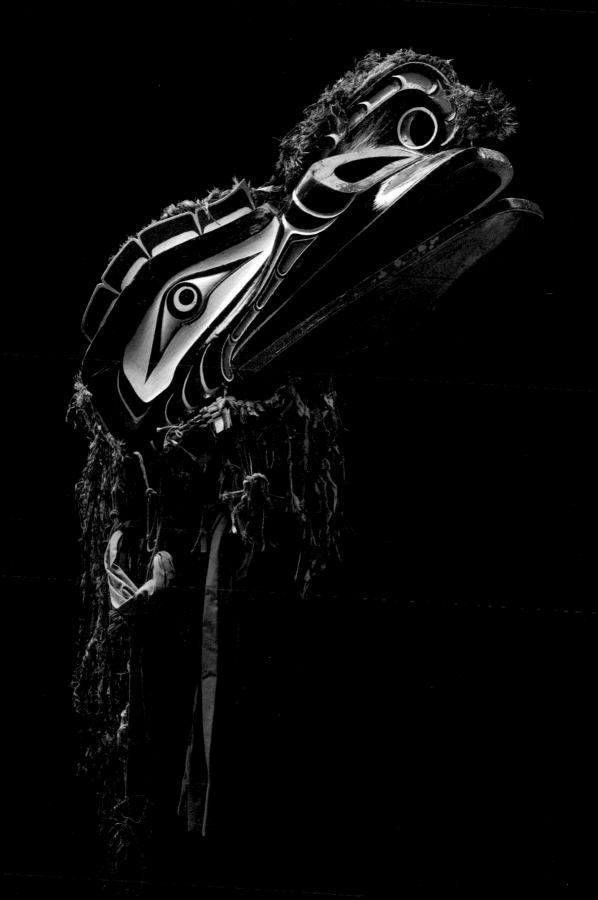

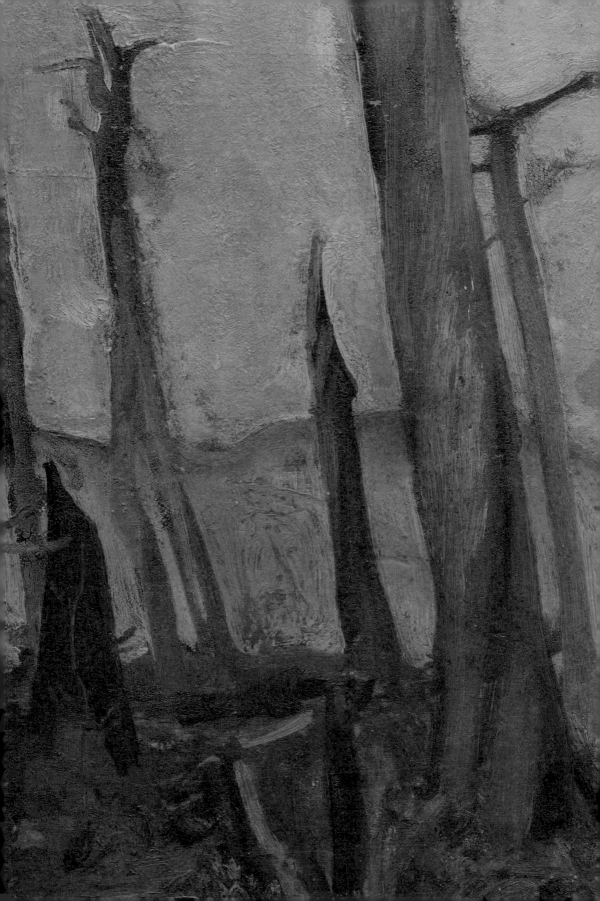

ARTIST **Frederick Varley**

AUTHOR Radclyffe Hall

Radclyffe Hall | The Well of Loneliness (excerpt)

Martin lived in British Columbia, it seemed, where he owned several farms
and a number of orchards. He had gone out there after the death of his
mother, for six months, but had stayed on for love of the country. And now
he was having a holiday in England—that was how he had got to know
young Roger Antrim, they had met up in London and Roger had asked him
to come down for a week, and so here he was—but it felt almost strange to
be back again in England. Then he talked of the vastness of that new country
that was yet so old; of its snow-capped mountains, of its canyons and gorges,
of its deep, princely rivers, of its lakes, above all of its mighty forests. And
when Martin spoke of those mighty forests, his voice changed, it became
almost reverential; for this young man loved trees with a primitive instinct,
with a strange and inexplicable devotion. Because he liked Stephen he could
talk of his trees, and because she liked him she could listen while he talked,
feeling that she too would love his great forests.

His face was very young, clean-shaven and bony; he had bony, brown
hands with spatulate fingers; for the rest, he was tall with a loosely knit
figure, and he slouched a little when he walked from much riding. But
his face had a charming quality about it, especially when he talked of his
trees; it glowed, it seemed to be inwardly kindled, and it asked for a real
and heart-felt understanding of the patience and the beauty and the good-
ness of trees—it was eager for your understanding. Yet in spite of this touch
of romance in his make-up, which he could not keep out of his voice at

moments, he spoke simply, as one man will speak to another, very simply, not trying to create an impression. He talked about trees as some men talk of ships, because they love them and the element they stand for...

A queer, sensitive fellow this Martin Hallam, with his strange love of trees and primitive forests, not a man to make many intimate friends, and in consequence a man to be lonely...

One day he said: "Don't think me quite mad, but if we survive death then the trees will survive it; there must be some sort of a forest heaven for all the faithful—the faithful of trees. I expect they take their birds along with them; why not? 'And in death they were not divided.'" Then he laughed, but she saw that his eyes were quite grave, so she asked him:

"Do you believe in God, Martin?"

And he answered: "Yes, because of His trees."

—1928

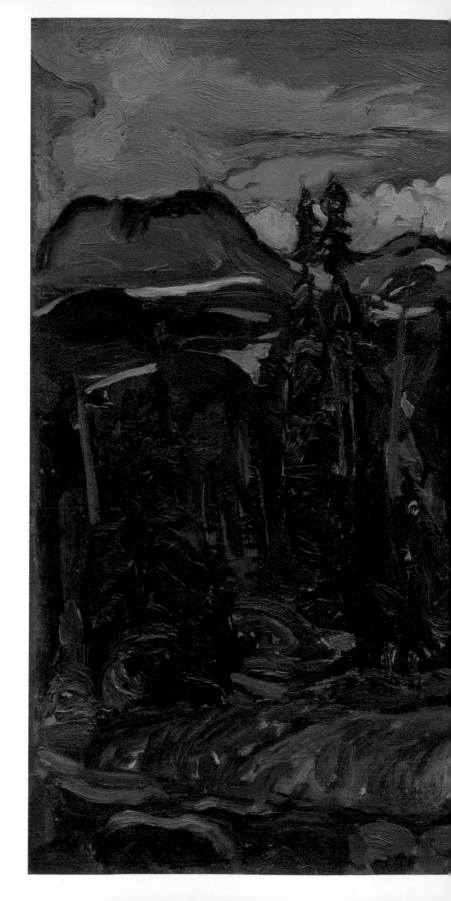

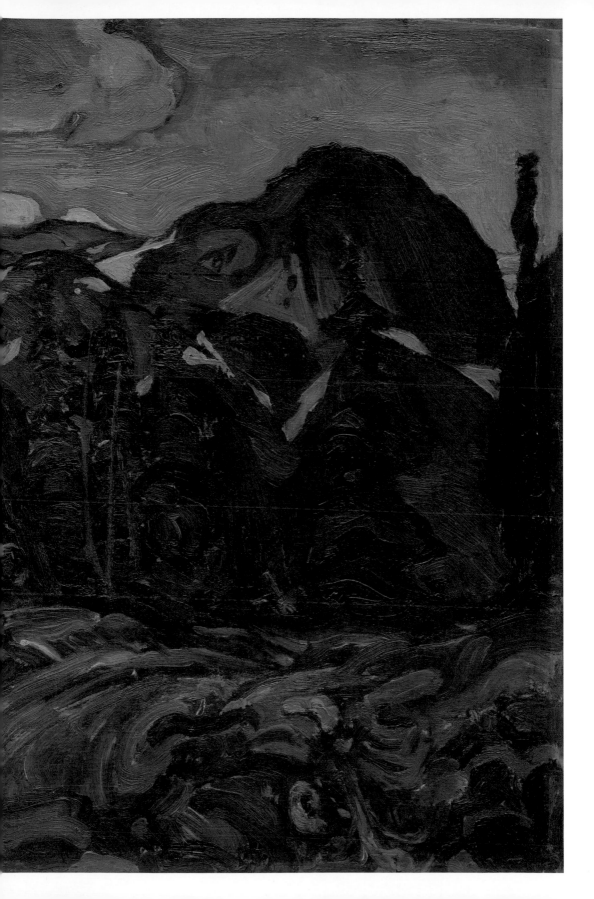

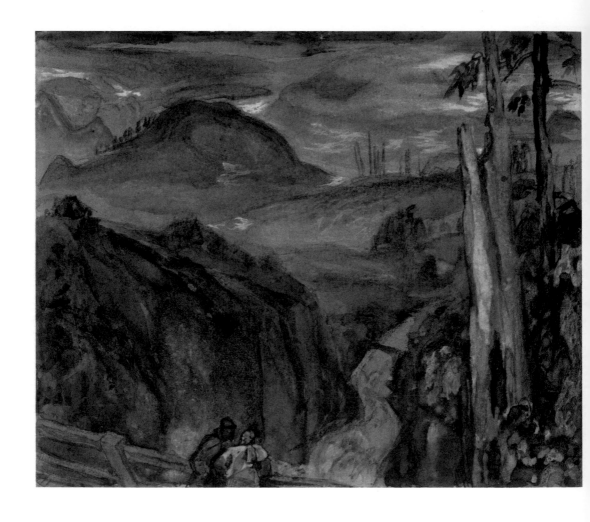

Frederick Horsman Varley | Bridge over Lynn Canyon, 1932–35

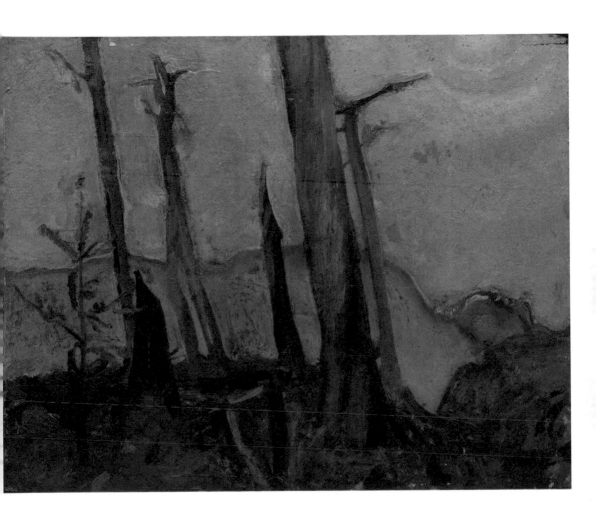

Frederick Horsman Varley | Blue Ridge, Upper Lynn, 1931–32

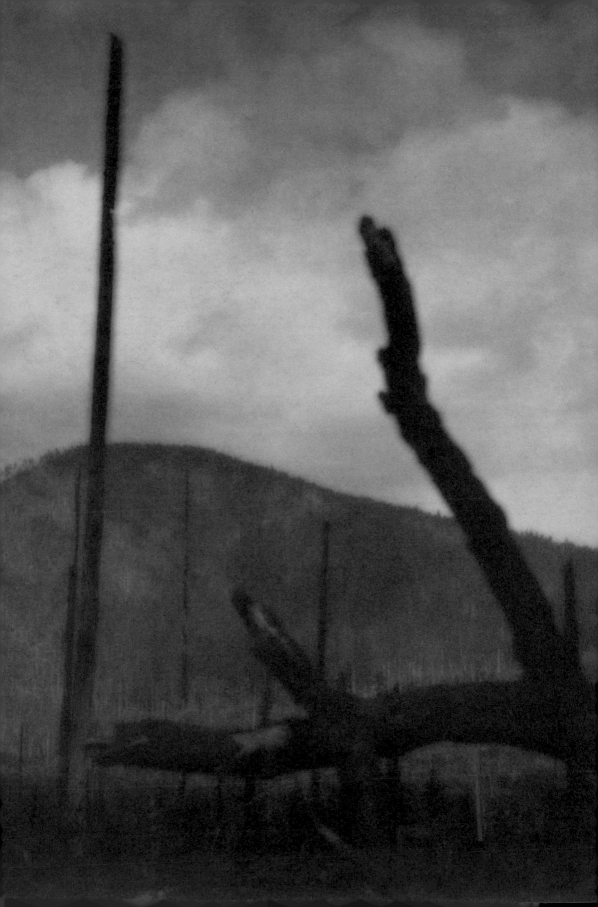

facing: **John Vanderpant** | **In the Wake of the Forest Fire**, 1926 (detail)

Hubert Evans | The Spark of Death (excerpt)

One noon a wind broke the quiet of the hidden valley. It charged up the lake, sending frightened cat's-paws scampering before it and buffeted the trees that walled the shore. It was hot, like the blast from some great furnace door, suddenly opened. Green twig tips and the shaded fronds of ferns seemed to cringe and wither before it.

Soon it found the spark of fire it wanted—a spark that had hidden, waiting and vicious, in the side of a sun-baked rotten log—and hurried it into flame. Within an hour a giant column of biting grey smoke had reared itself higher than the sheltering hills and was spreading like a colossal grey toadstool, against the flattened, copper sky. Baffled and angry, the sun hung poised above it, peering vainly at the increasing havoc below.

The fire from the rotten log spread like an opening fan as it raced to keep pace with the wind. The growling advance guard of the flame paused only long enough to deal slashing blows at the sun-heated timber, then leaped ahead, an insatiable demon, biting and throwing aside each morsel for the wall of slower fire that followed, like a dense pack of jackals, to feast upon the stricken victims. A premature, eerie twilight crept below the low cover of sullen smoke that back-eddied and filtered flakes of grey ash on the pallid water; now and then a twig, glowing and hot, fell to the water with a choking hiss.

That night the army of fire had passed up the valley, marching more leisurely now, confident of victory and unhindered pillage. Where the mature forest had been, charred stubs glowed evenly or stabbed the red night with sudden jets of searching flames. The bottom land, and the sidehills that held it, were like a vast city that had been looted and left. Occasionally the fearsome, muttering night-hush was shattered by the wrenching crash of a giant tree whose butt had been gnawed through by the worms of fire. Half-moon Creek bore heavy loads of charred limbs and bark and left them to circle in the lake at either side of its mouth.

—1930

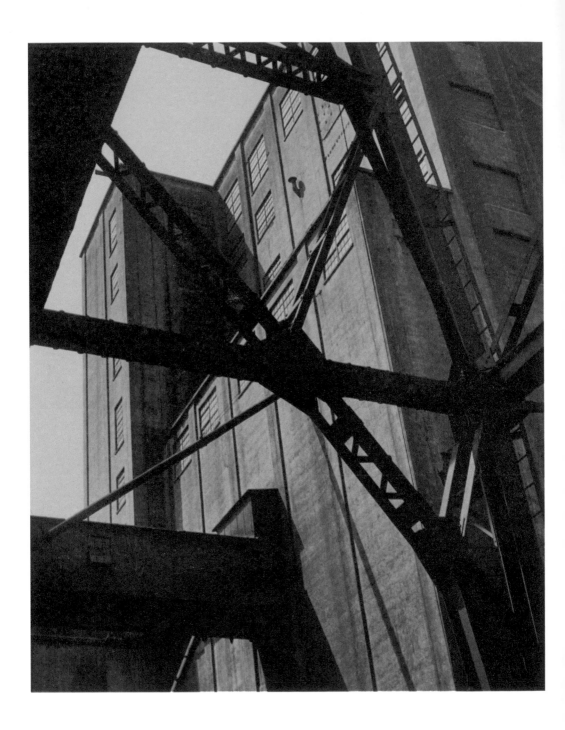

John Vanderpant | Untitled (Steel), 1934

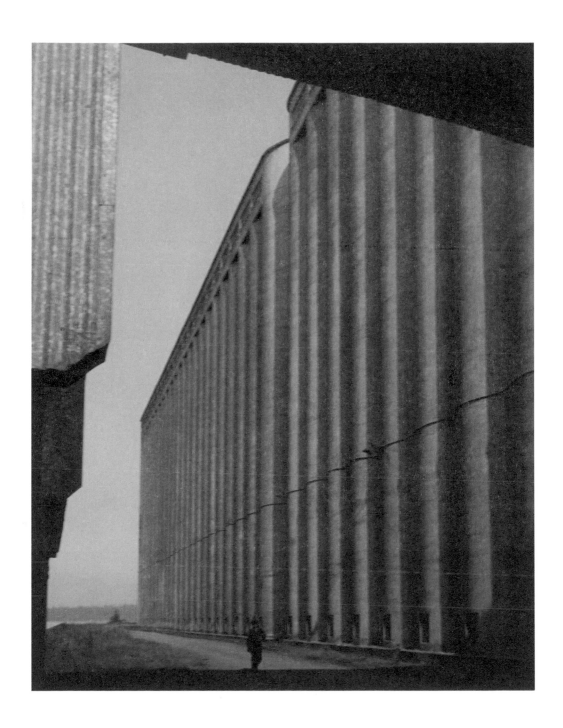

John Vanderpant | Temples on the Sea Shore, no date

47

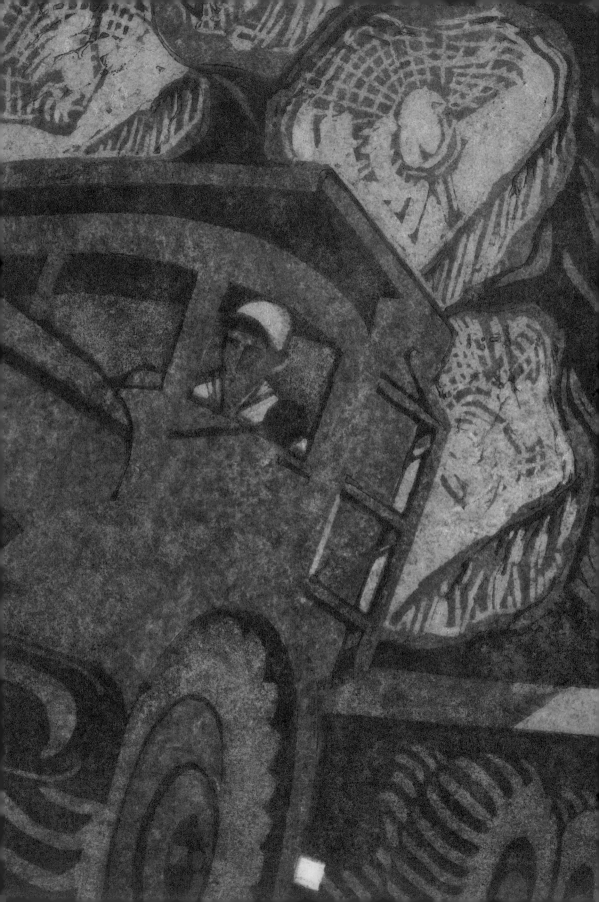

ARTIST **Sybil Andrews**

AUTHOR John Vaillant

facing: **Sybil Andrews** | **Logging Team**, 1952 (detail)

John Vaillant | The Golden Spruce (excerpt)

On both sides of the border the forests of the Northwest were still being treated like a kind of inexhaustible golden goose. The relationship between local governments and the timber industry was generally one of self-serving collusion with the emphasis being on volume and speed; the working motto was "Get the cut out." It was nothing to clear-cut both sides of an entire valley and simply move on to the next; in fact, it was standard procedure— decade after decade, and valley after valley. After all, there were so many, especially in British Columbia.

By any measure, British Columbia is an absolutely enormous place; it occupies two time zones and is bigger than 164 of the world's countries. All of California, Oregon, and Washington could fit inside it with room left over for most of New England. From end to end and side to side, the province is composed almost entirely of mountain ranges that are thickly wooded from valley bottom to tree line. Even today it is hard country to navigate; the drive from Vancouver, in the southwest corner, to Prince Rupert, halfway up the coast, takes twenty-four hours—weather permitting. There are only two paved roads accessing its northern border, and one of them is the Alaska Highway. B.C.'s coastline—including islands and inlets—is twenty-seven thousand kilometres long, and all of it was once heavily forested, in most cases down to the waterline.

Like Alaska, this landscape exudes an overwhelming power to diminish all who move across it. A colony of 500-kilogram sea lions might as well be a cluster of maggots, and a human being nothing but an animated pouch of plasma for feeding mosquitoes. That something as small as a man could have any impact on such a place seems almost laughable. In a geography of this magnitude, one can imagine how it might have been possible to believe that the West Coast bonanza would never end. And the numbers bear this out; British Columbia's timber holdings were truly awe-inspiring: in 1921, after more than sixty years of industrial logging, an estimate of the province's remaining timber came in at 366 billion board feet—enough wood to build twenty million homes, or a boardwalk to Mars.

—2005

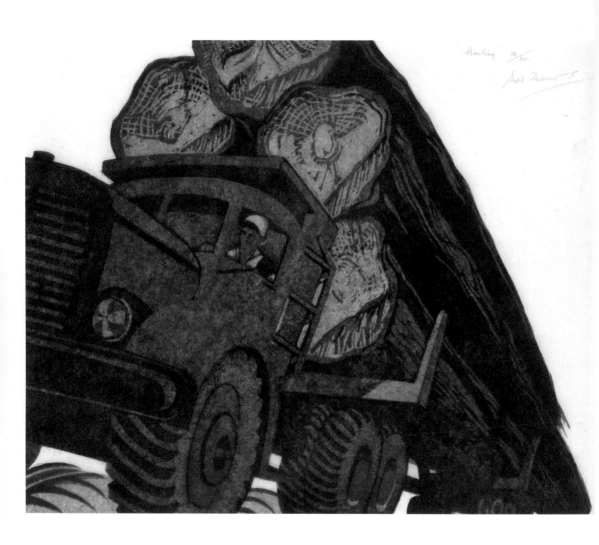

Sybil Andrews | Logging Team, 1952

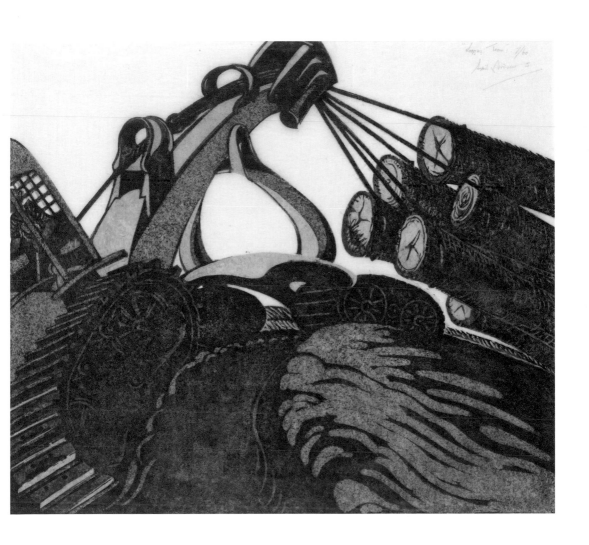

Sybil Andrews | Hauling, 1952

53

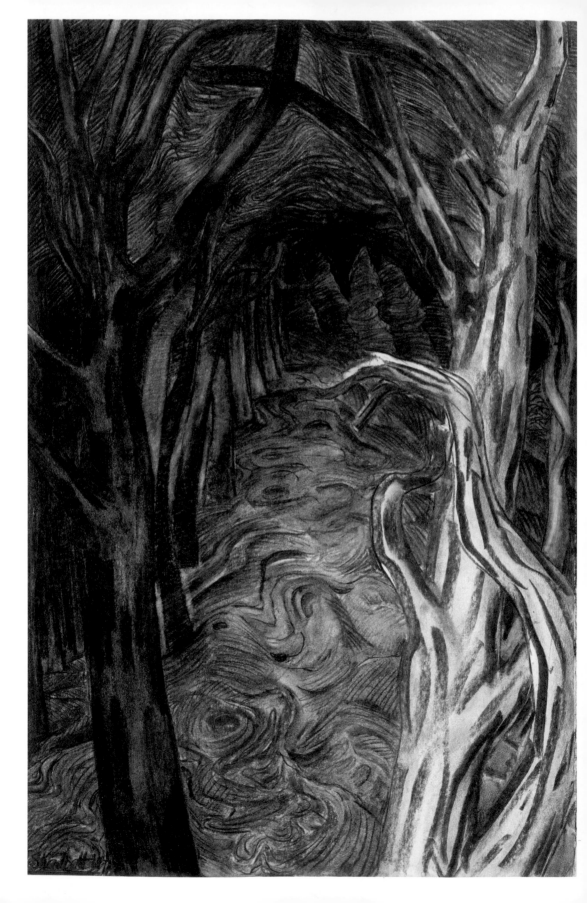

ARTIST **Jack Shadbolt**

AUTHOR Emily Carr

facing: **Jack Shadbolt** | Hornby Suite, 1971

Emily Carr | Hundreds and Thousands (excerpt)

JUNE 17, 1931

I am always asking myself the question, What is it you are struggling for?
What is that vital thing the woods contain, possess, that you want? Why
do you go back and back to the woods unsatisfied, longing to express
something that is there and not able to find it? This I know, I shall not find it
until it comes out of my inner self, until the God quality in me is in tune with
the God in it. Only by right living and a right attitude towards my fellow man,
only by intense striving to get in touch, in tune with, the Infinite, shall I find
that deep thing hidden there, and that will not be until my vision is clear
enough to see, until I have learned and fully realize my relationship
to the Infinite.

NOVEMBER 3, 1932

So, the time moves on, I with it. This evening I aired the dogs and took tea on the beach. It had rained all the earlier day and the wood was too soaked to make a fire, but I sat on the rocks and ate and drank hot tea and watched the sun set, with the waves washing near to my feet. The dogs, Koko, Maybbe and Tantrum, were beloved, cuddly close, and all the world was sweet, peaceful, lovely. Why don't I have a try at painting the rocks and cliffs and sea? Wouldn't it be good to rest the woods? Am I one-idea'd, small, narrow? God is in them all. Now I know that is all that matters. The only thing worth striving for is to express God. Every living thing is God made manifest. All real art is the eternal seeking to express God, the one substance out of which all things are made. Search for the reality of each object, that is, its real and only beauty; recognize our relationship with all life; say to every animate and inanimate thing "brother"; be at one with all things, finding the divine in all; when one can do all this, maybe then one can paint. In the meantime one must go steadily on with open mind, courageously alert, waiting always for a lead, constantly watching, constantly praying, meditating much and not worrying.

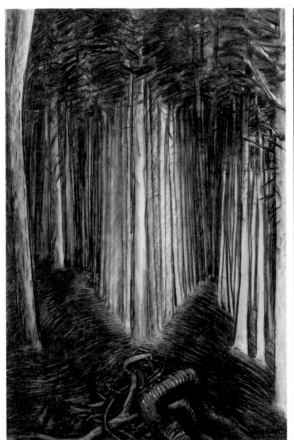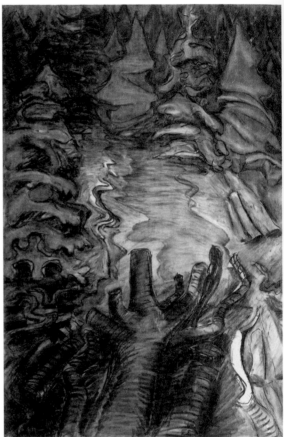

Jack Shadbolt | Hornby Suite, 1971

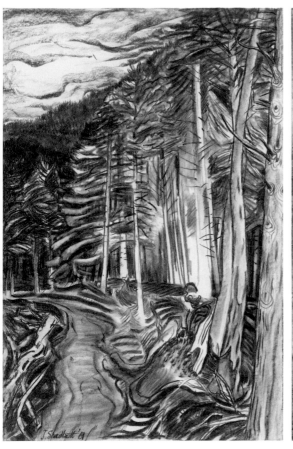
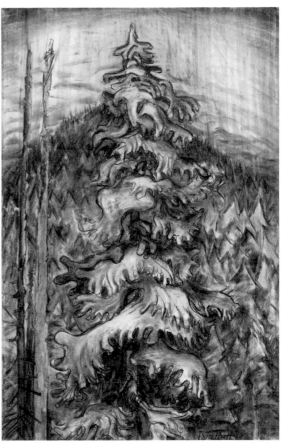

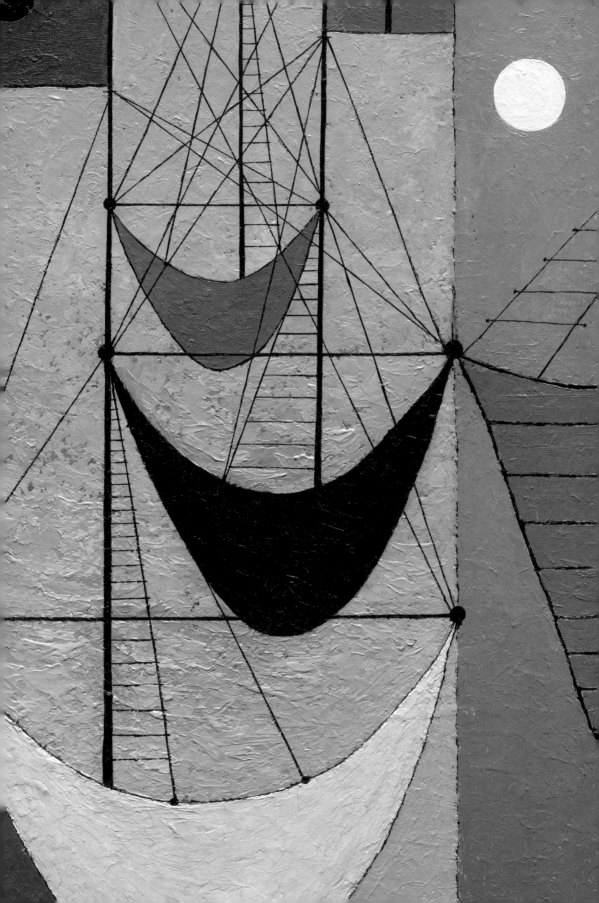

ARTIST **B.C. Binning**

AUTIIOR Malcolm Lowry

Malcolm Lowry | Happiness

Blue mountains with snow and blue cold rough water,
A wild sky full of stars at rising
And Venus and the gibbous moon at sunrise,
Gulls following a motorboat against the wind,
Trees with branches rooted in air—
Sitting in the sun at noon with the furiously
Smoking shadow of the shack chimney—
Eagles drive downwind in one,
Terns blow backward,
A new kind of tobacco at eleven,
And my love returning on the four o'clock bus
—My God, why have you given this to us?

—c. 1950–54

facing: **B.C. Binning** | Garden Potting Shed, c. 1945

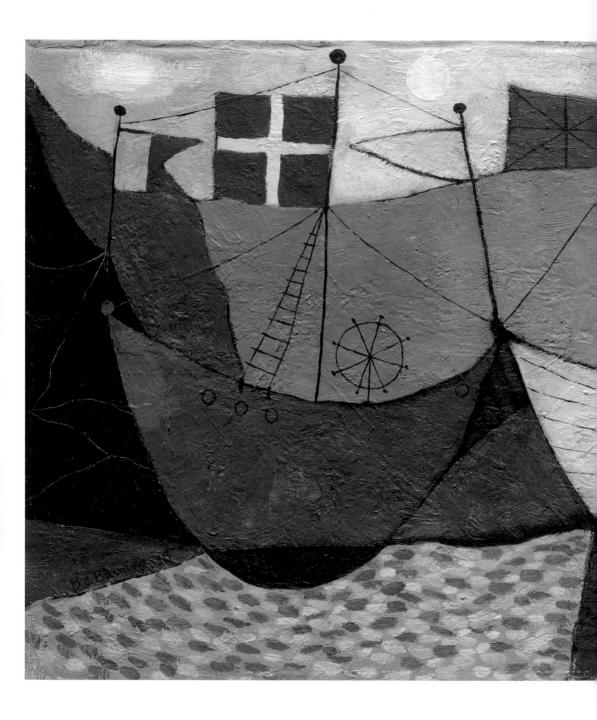

B.C. Binning | Convoy at Rendezvous, 1948

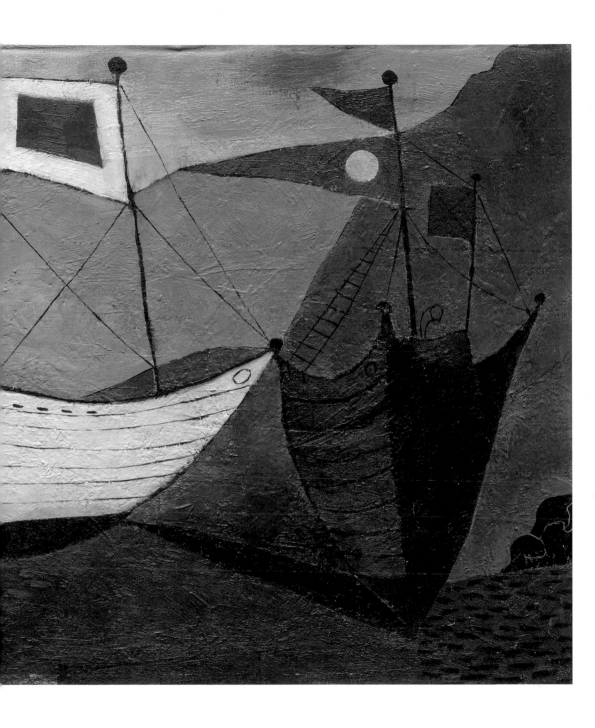

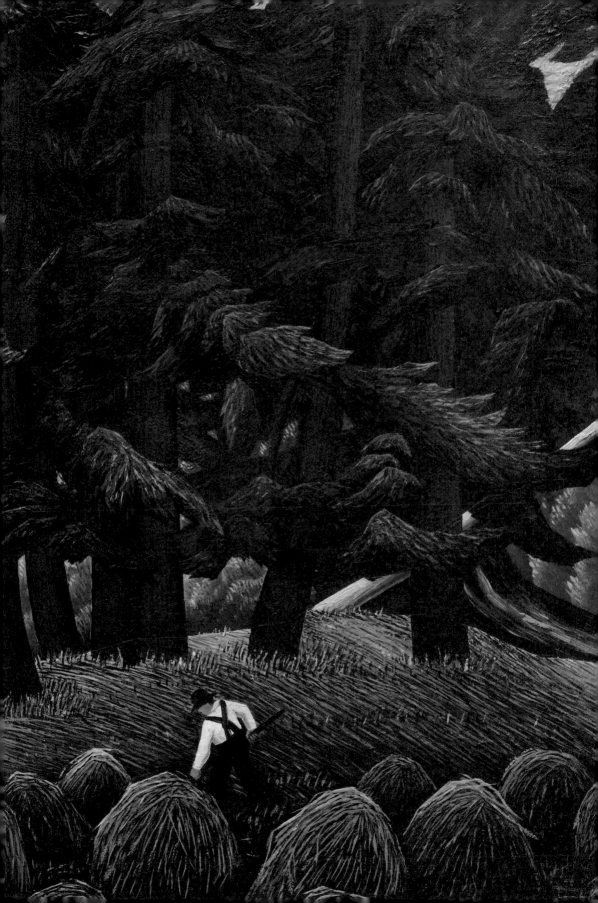

ARTIST **E.J. Hughes**

AUTHOR Audrey Thomas

facing: **E.J. Hughes** | **Farm near Courtenay, B.C.**, 1949 (detail)

Audrey Thomas | The Man with Clam Eyes (excerpt)

I came to the sea because my heart was broken. I rented a cabin from an old professor who stammered when he talked. He wanted to go far away and look at something. In the cabin there is a table, a chair, a bed, a woodstove, an aladdin lamp. Outside there is a well, a privy, rocks, trees and the sea.

(The lapping of waves, the scream of gulls.)

I came to this house because my heart was broken. I brought wine in green bottles and meaty soup bones. I set an iron pot on the back of the stove to simmer. I lit the lamp. It was no longer summer and the wind grieved around the door. Spiders and mice disapproved of my arrival. I could hear them clucking their tongues in corners.

(The sound of the waves and the wind.)

This house is spotless, shipshape. Except for the spiders. Except for the mice in corners, behind walls. There are no clues. I have brought with me wine in green bottles, an eiderdown quilt, my brand-new *Bartlett's Familiar Quotations*. On the inside of the front jacket it says, "Who said: 1. In wilderness is the preservation of the world. 2. All hell broke loose. 3. You are the sunshine of my life."

I want to add another. I want to add two more. Who said, "There is no nice way of saying this?" Who said, "Let's not go over it again?" The wind grieves around the door. I stuff the cracks with green rags torn from the bottom of my skirt. I am sad. Shall I leave here then? Shall I go and lie outside his door calling whoo—whoo—whoo like the wind?

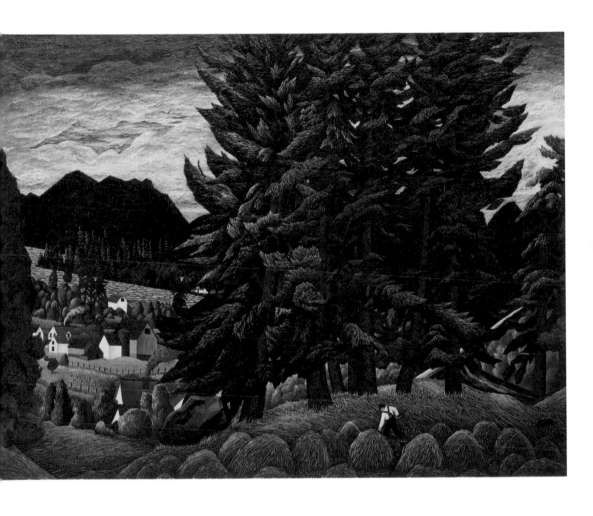

E.J. Hughes | Farm near Courtenay, B.C., 1949

(The sound of the waves and the wind.)

I drink all of the wine in one green bottle. I am like a glove. Not so much shapeless as empty, waiting to be filled up. I set my lamp in the window, I sleep to the sound of the wind's grieving.

(Quiet breathing the wind still there, but
 soft, then gradually fading out. The passage
 of time, then seagulls, and then waves.)

How can I have slept when my heart is broken? I dreamt of a banquet table under green trees. I was a child and ate ripe figs with my fingers. Now I open the door—

(West-coast birds, the towhee with
 its strange cry, and the waves.)

—1986

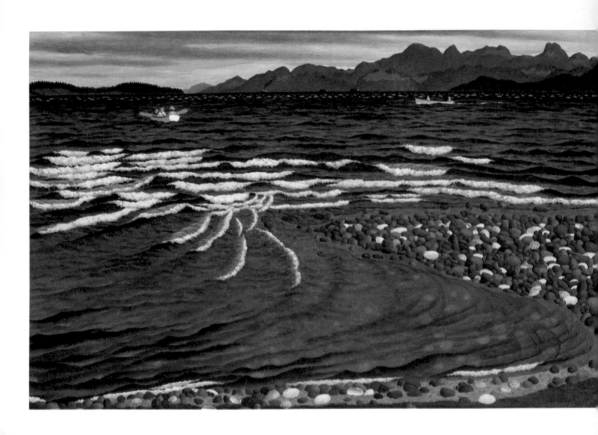

E. J. Hughes | Qualicum, 1958

ARTIST **Gordon Smith**

AUTHOR Malcolm Lowry

facing: **Gordon Smith** | Barkley Sound, 1987

Malcolm Lowry | The Forest Path to the Spring (excerpt)

At dusk, every evening, I used to go through the forest to the spring for water.

The way that led to the spring from our cabin was a path wandering along the bank of the inlet through snowberry and thimbleberry and shallon bushes, with the sea below you on the right, and the shingled roofs of the houses, all built down on the beach beneath round the little crescent of the bay.

Far aloft gently swayed the mastheads of the trees: pines, maples, cedars, hemlocks, alders. Much of this was second growth but some of the pines were gigantic. The forest had been logged from time to time, though the slash the loggers left was soon obliterated by the young birch and vines growing up quickly.

Beyond, going towards the spring, through the trees, range beyond celestial range, crowded the mountains, snow-peaked for most of the year. At dusk they were violet, and frequently they looked on fire, the white fire of the mist. Sometimes in the early mornings this mist looked like a huge family wash, the property of Titans, hanging out to dry between the folds of their lower hills. At other times all was chaos, and Valkyries of storm-drift drove across them out of the ever reclouding heavens.

Often all you could see in the whole world of the dawn was a huge sun with two pines silhouetted in it, like a great blaze behind a Gothic cathedral. And at night the same pines would write a Chinese poem on the moon. Wolves howled from the mountains. On the path to the spring the mountains appeared and disappeared through the trees.

And at dusk, too, came the seagulls, returning homeward down the inlet from their daily excursion to the city shores—when the wind was wailing through the trees, as if shot out of a catapult.

Ceaselessly they would come flying out of the west with their angelic wings, some making straight down the inlet, others gliding over the trees, others slower, detached, staggering, or at a dreadfully vast height, a straggling marathon of gulls.

On the left, half hidden among the trees in monolithic attitudes of privacy, like monastic cells of anchorites or saints, were the wooden backhouses of the little shacks.

This was what you could see from the path, which was not only the way to the spring but a fraction of the only footpath through the forest between the different houses of Eridanus, and when the tide was high, unless you went by boat, the only way round to your neighbours.

Not that we had any neighbours to speak of.

—1949–54

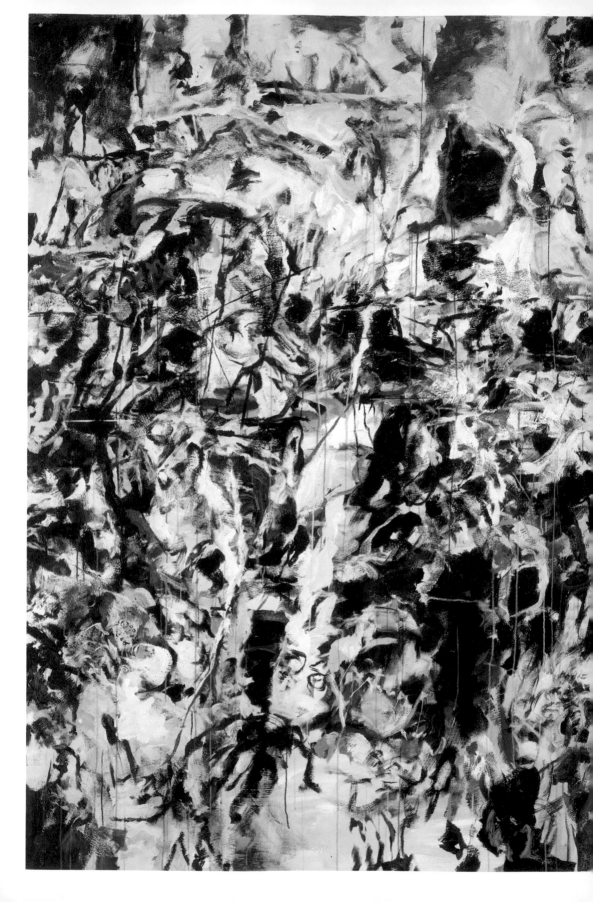

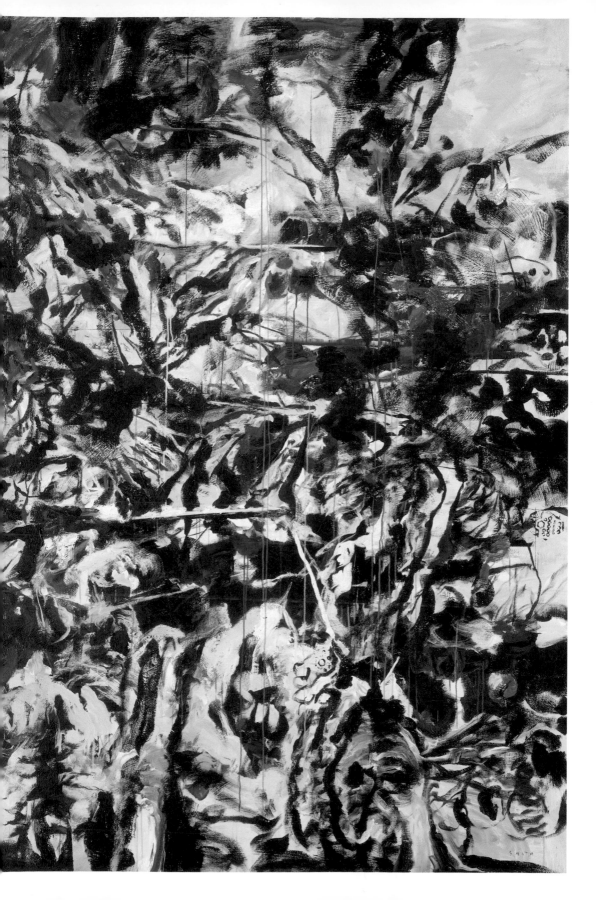

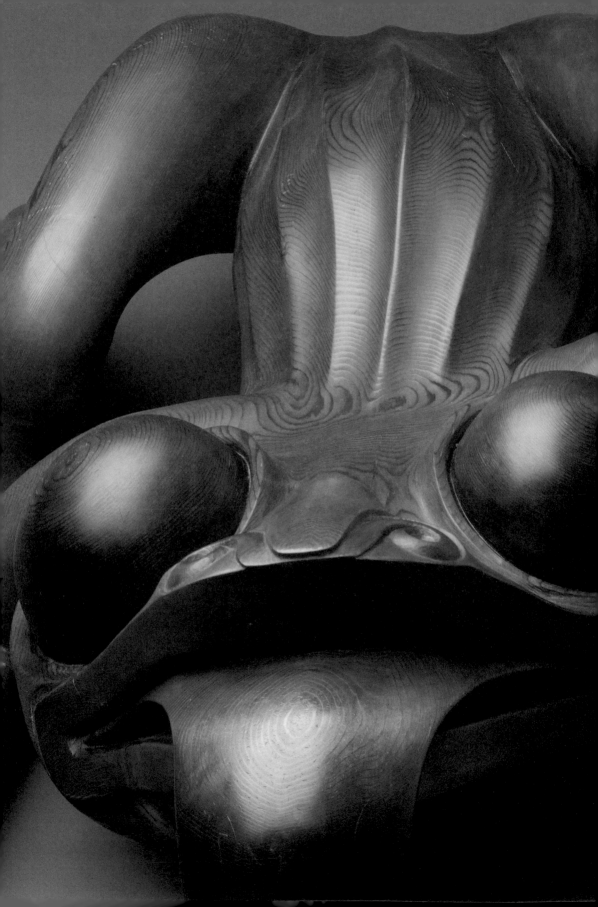

ARTIST **Bill Reid**

AUTHOR Guujaaw

facing: **Bill Reid** | **Phyllidula—The Shape
of Frogs to Come**, 1984–85 (detail)

Guujaaw | This Box of Treasures

. . . and know
that Haida Culture is not simply song and dance,
graven images, stories, language, or even blood.
It's all of these things and then . . .
awakening on Haida Gwaii,
. . . waiting for the herring to spawn.
It's a feeling you get when you bring a feed of cockles to the old people,
and fixing up fish for the smokehouse
. . . walking on barnacles, or moss.
It has something to do with bearing witness as a falcon gets a
seabird . . .
and being there when salmon are finishing their course.
Along the way, you eat some huckleberries,
watch the kids grow up . . . attend the funeral feasts.
It's a matter of dealing with the squabbles within
and the greater troubles that come to us from the outside.
It is about being confronted by the great storms of winter
and trying to look after this precious place.

—2006

facing: **Bill Reid** | Bear, 1981

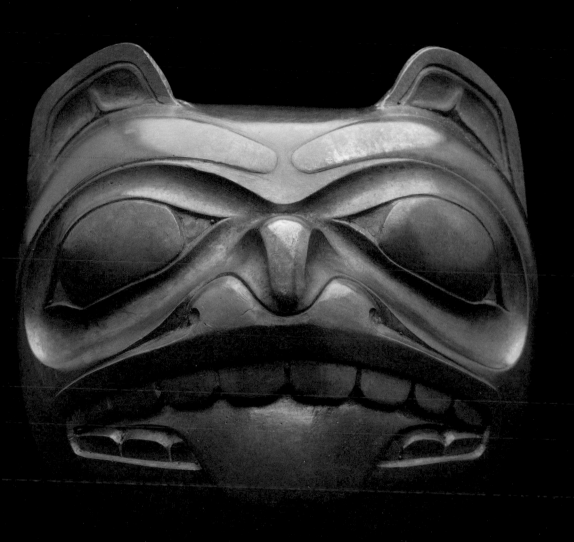

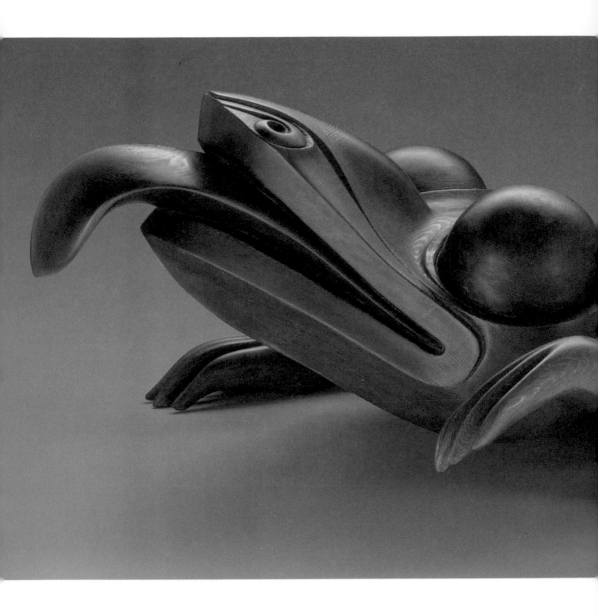

Bill Reid | Phyllidula—The Shape of Frogs to Come, 1984–85

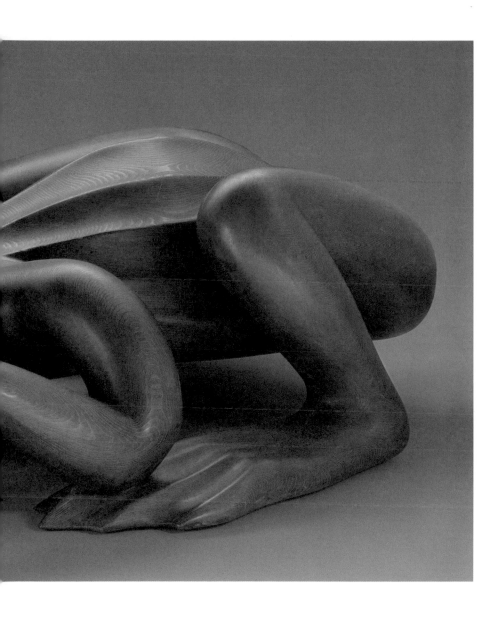

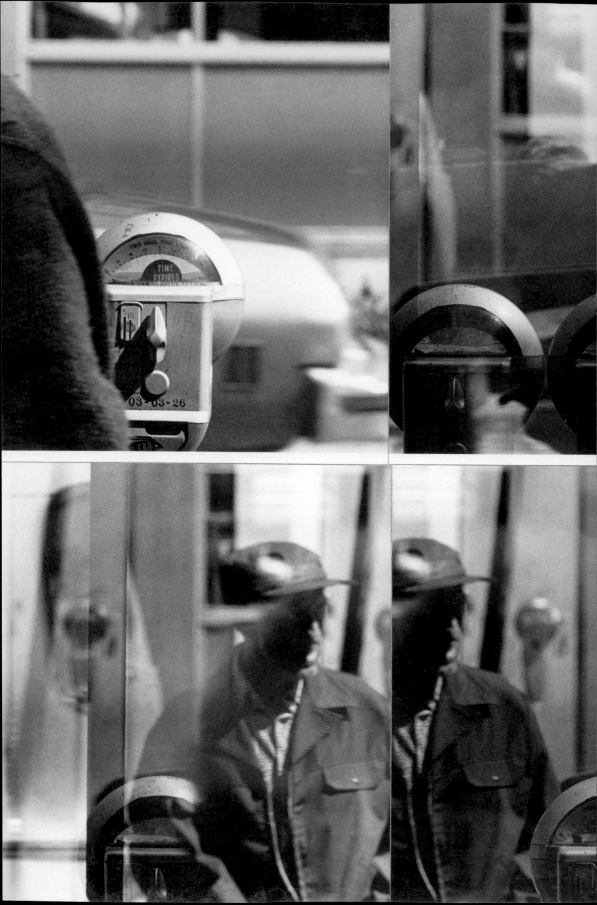

ARTIST **Roy Kiyooka**
AUTHOR Roy Kiyooka

facing: **Roy Kiyooka** | Untitled (Opposite Blue
Mule Studio, Powell Street), 1978–80 (detail)

Roy Kiyooka | Pear Tree Pome

just the other day i ate up the last bowlful of

your preserved pears and wasn't it just the day before
'yesterday' we stood in the back-alley looking up
at its array of white blossoms and under our breath say
how lucky we are to find such a splendid clapboard
house with its own tall pear tree . eight brimfilld years
spoke to me as i put the last sliver in my mouth and
suckt up all the sweet pear juice . from here on in i'll
have to go it alone if i'm to compost another spring .
i'll miss your preserved pears your paring knife and son .

p/s there's a dozen pears rotting on top of the camper

—1987

facing: **Roy Kiyooka** | Back Alley (stills), 1978

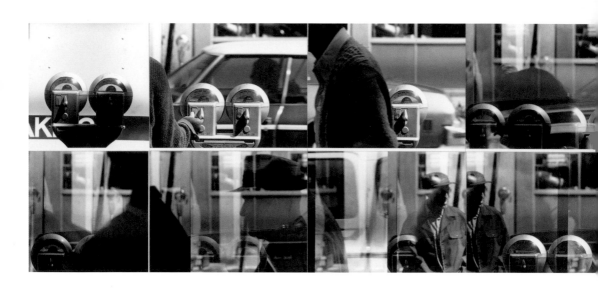

Roy Kiyooka | Untitled (Opposite Blue
Mule Studio, Powell Street), 1978–80

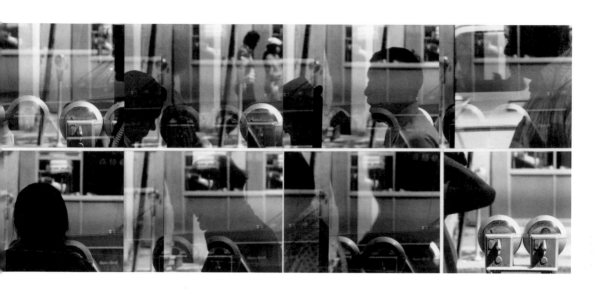

ARTIST **Gathie Falk**

AUTHOR Ethel Wilson

facing: **Gathie Falk** | **Piece of Water: Libya**, 1981 (detail)

Ethel Wilson | Hetty Dorval (excerpt)

What gives Lytton its especial character, lying there at the fringe of the sage-brush carpet in a fold of the hills at the edge of the dry belt and the coast area, is that just beside the town the clear turbulent Thompson River joins the vaster opaque Fraser. The Fraser River, which begins as a sparkling stream in the far northern mountains, describes a huge curve in northern British Columbia, and, increased in volume by innumerable rills and streams and by large and important tributary rivers, grows in size and reputation and changes its character and colour on its journey south.

Long before the Fraser reaches Lytton it has cut its way through different soils and rocks and has taken to itself tons of silt, and now moves on, a wide deceptive flow of sullen opaque and fawn-coloured water. Evidences of boil and whirlpool show the river to be dangerous. At Lytton it is refreshed and enlarged by the blue-green racing urgent Thompson River. This river in the course of its double journey from north and east spreads itself into lakes and gathers itself together again into a river, until as it approaches Lytton it manifests all its special beauty and brilliance . . .

Ever since I could remember, it was my joy and the joy of all us to stand on this strong iron bridge and look down at the white line where the expanse of emerald and sapphire dancing water joins and is quite lost in the sullen Fraser. It is a marriage, where, as often in marriage, one overcomes the other, and one is lost in the other. The Fraser receives all the startling colour of the

Thompson River and overcomes it, and flows on unchanged to look upon, but greater in size and quality than before. Ernestine and I used to say, "Let's go down to the Bridge," and there we would stand and lean on the railing and look down upon the hypnotizing waters . . . We would turn and again look down at the bright water being lost in the brown, and as we talked and laid our little plans of vast importance for that day and the next, the sight of the cleaving joining waters and the sound of their never-ending roar and the feel of the frequent Lytton wind that blew down the channels of both the rivers were part and parcel of us, and conditioned, as they say, our feeling.

—1947

Gathie Falk | Cement with Black Shadow, 1983

Gathie Falk | *Piece of Water: Libya,* 1981

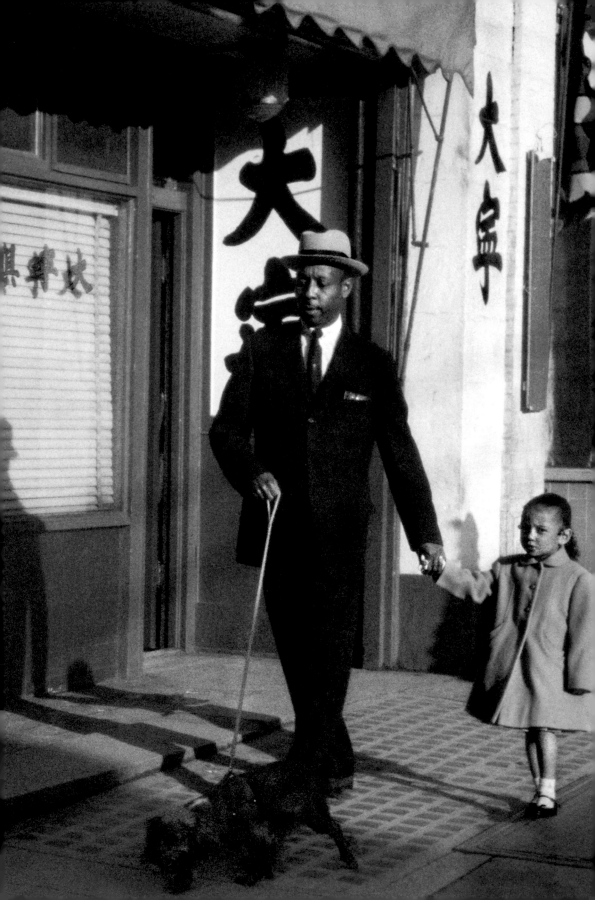

ARTIST **Fred Herzog**

AUTHOR Wayson Choy

facing: **Fred Herzog** | Black Man Pender, 1958 (detail)

Wayson Choy | The Jade Peony (excerpt)

I knew that every brick in Chinatown's three- and five-storey clan buildings lay like the Great Wall against anyone knowing everything. The *lao wah-kiu*— the old-timers who came overseas from Old China—hid their actual life histories within those fortress walls. Only paper histories remained, histories blended with talk-story...

I wondered if all the clapboard houses along the street harboured as many whispers as our house did. Those damp shacks decaying on their wooden scaffolding, whose doors you reached only by negotiating rickety ramps—all the one- and two-storey houses parallel along Pender and Keefer, Georgia and Union—did each of those broken, scarred doors lock in their share of whisperings? Some nights I would hear in my dreams our neighbours' whisperings rising towards the ceiling, Jewish voices, Polish and Italian voices, all jostling for survival, each as desperate as Chinese voices.

—1995

facing: **Fred Herzog** | Fishseller, 1958
overleaf: **Fred Herzog** | Westend from Burrard Bridge, 1957

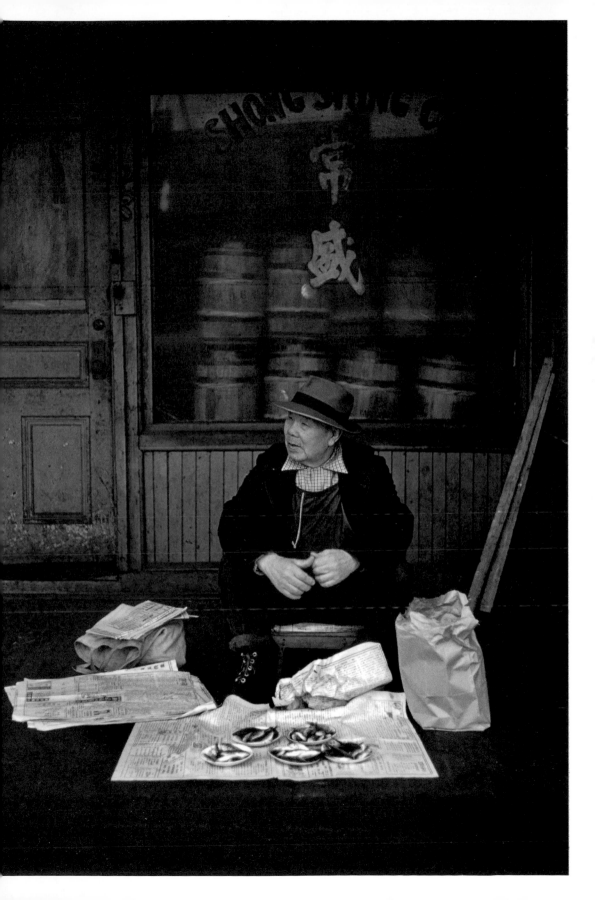

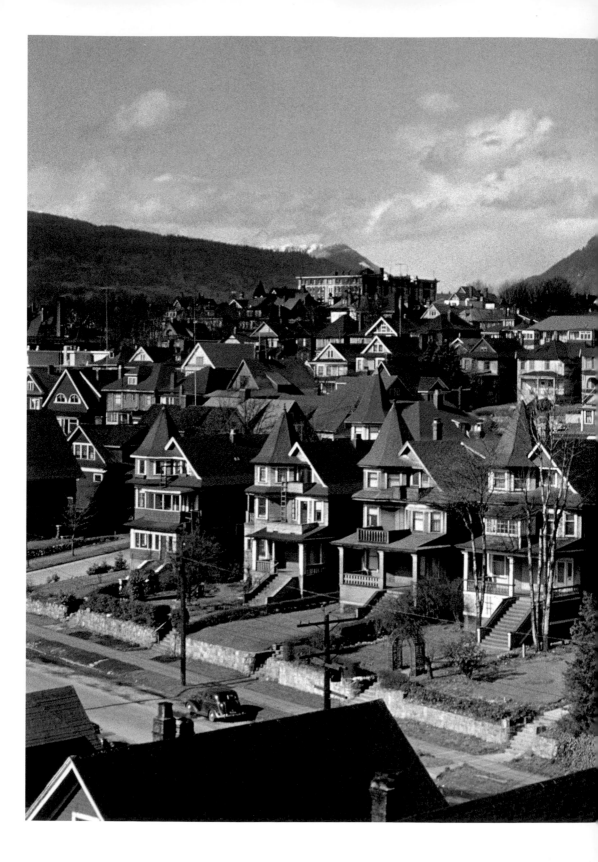

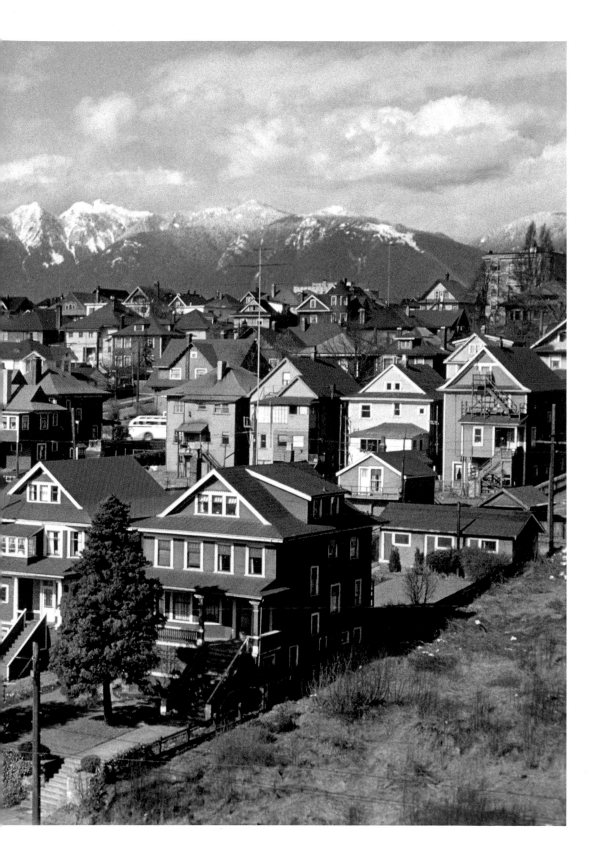

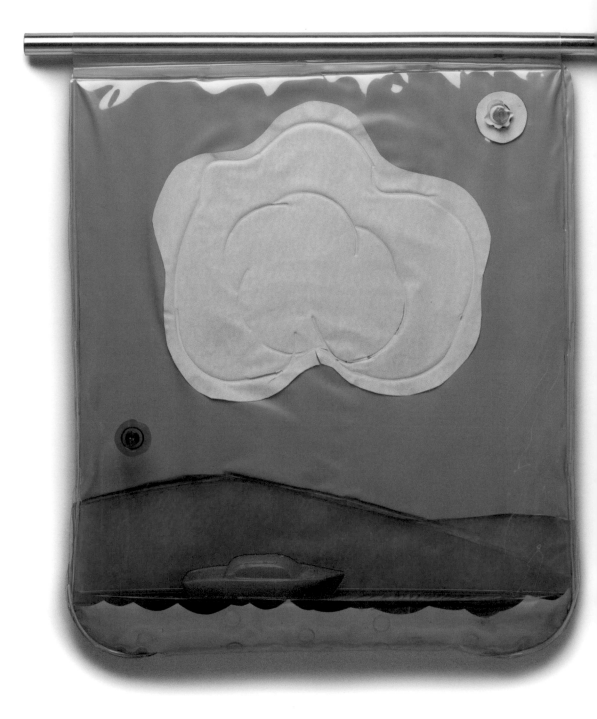

ARTISTS **N.E. Thing Co.**

AUTHOR **bill bissett**

facing: **Ingrid Baxter and Iain Baxter** | Bagged Landscape, 1966

bill bissett | killer whale

"...i want to tell you love..."
—Milton Acorn

we were tryin to get back to Vancouver
again cumming down th sunshine coast, away
speeding from th power intrigue of a
desolate town, Powell River, feudalizd
totally by MacMillan Blowdell, a different
trip than when i was hitch-hiking back
once before with a cat who usd to live
next door to Ringo Starr's grandmother
who still lives in th same Liverpool house
even tho Ringo offerd her a town house
in London, still shops at th same places
moves among th Liverpool street
with th peopul, like she dusint want
to know, this cat told me

away from th robot stink there,
after th preliminary hearing, martina
and me and th hot sun, arguing
our way thru th raspberry bushes
onto a bus headin for Van, on th ferry
analyzing th hearing and th bust, how

th whole insane trip cuts at our life
giving us suspicions and knowledge
stead of innocence and th bus takes
off without us from th bloody B.C.
government ferry—i can't walk too good
with a hole in my ankle and all why
we didn't stay with our friends back
at th farm—destind for more places
changes to go thru can feel th pull
of that heavy in our hearts and in th air,
th government workmen can't drive us
20 minutes to catch up with th bus, insane
complications, phoning Loffmark works minister
in Victoria capital if he sz so they will they say
he once wrote a fan letter to me on an
anti-Vietnam pome published in Prism, "...with
interest..." he sd he read it, can't get him
on th phone, workmen say yer lucky if th
phone works, o lets dissolve all these phone
booths dotting surrealy our incognito intrigue
North American vast space, only cutting us all
off from each other—more crap with th bus
company, 2 hrs later nother ferry, hitch
ride groovy salesman of plastic bags, may
be weul work together we all laughing say
in th speeding convertibel to Garden City, he
wants to see there th captive killer whales.

Down past th town along th fishing boat dock
th killer whales, like Haida argolite carvings,
th sheen—black glistening, perfect white circuls
on th sides of them, th mother won't feed
th baby, protests her captivity, why did they

cum into this treacherous harbor, th times
without any challenge, for food, no food
out there old timer tells me, and caught,
millions of bait surrounding them, part of
th system, rather be food for th despondent
killer whales than be eat by th fattend ducks
on th shore there old timer tells me, and
if th baby dies no fault of mine th man
hosing him down strappd in a canvas sack
so he won't sink to th bottom, ive been hosing
him down 24 hrs a day since we netted em,
and out further a ways more killer whales
came in to see what was happening and they
got capturd for their concern, th cow howling
,thrashing herself in and out of th water, how
like i felt after getting busted, like as all
felt, yeah, th hosing down man told me, we got
enuff killer whales for 2 maybe 3 museums, course
th baby may die but there's still plenty for those
peopul whos never see animals like these
here lessen they went to a museum.

We went back to th convertible along th narrow
plank, heard th cow howl sum more, th bull
submergd, th man hosing th listless baby,
th sun's shattering light, them mammals aren't going
to take it lying down we thot, missd another ferry
connection, changd, made it, staggerd
together into town.

—1971

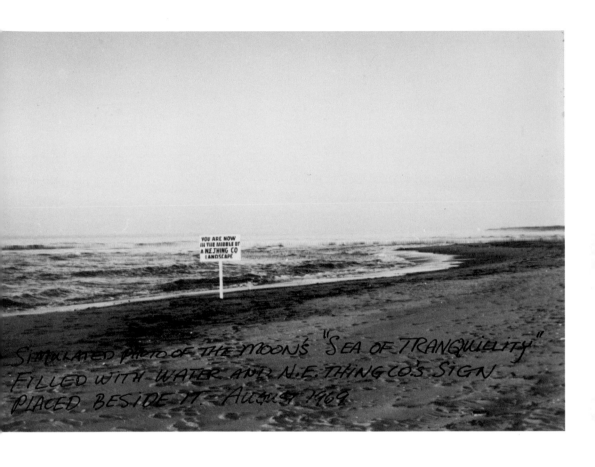

N.E. Thing Co. (Ingrid Baxter and Iain Baxter) | You Are Now
in the Middle of an N.E. Thing Company Landscape, c. 1968

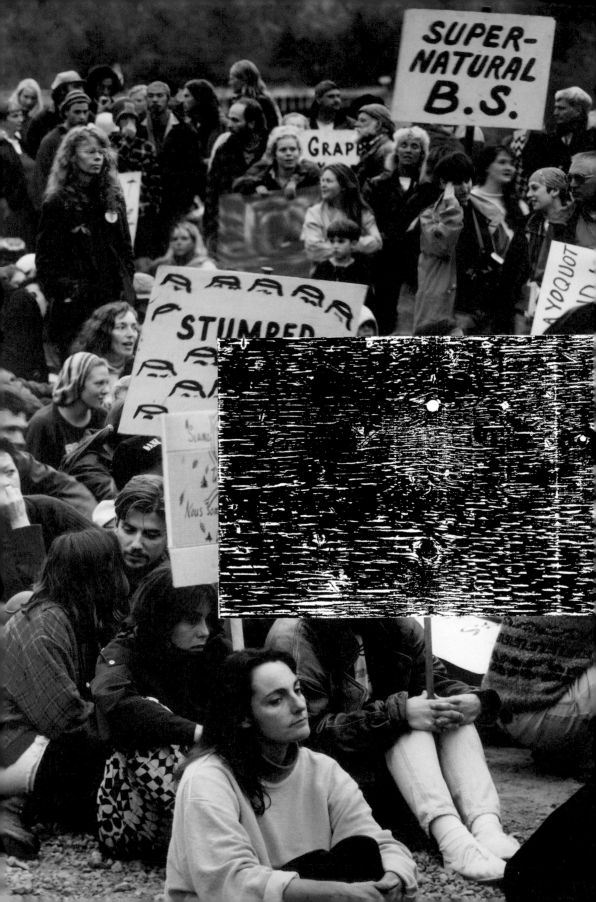

ARTIST **Ian Wallace**

AUTHOR Maurice Gibbons

facing: **Ian Wallace** | **Clayoquot Protest**
(**August 9, 1993**) I, 1993–95 (detail)

Maurice Gibbons | The Clayoquot Papers (excerpt)

On August 9, 1994, my wife, Margot, and I were arrested at the Kennedy River Bridge in Clayoquot Sound for refusing to obey a court injunction against obstructing logging operations of the MacMillan Bloedel employees in the area. We are not activists; we have never been arrested before; we were deeply shaken by the experience...

 We arrived just in time to join a cavalcade of cars, trucks and buses carrying over one thousand people as it turned off the highway onto a dusty logging road heading for the Bridge. After several kilometres, marshalls told us to pull over, park and wait. As the crowd gathered in the breaking dawn, the drums and singing began. Nothing had really happened yet, but I felt my heart thumping...

 We began reaching out to each other and introducing ourselves—a secretary, two teachers, another professor, a corporate accountant, a nurse, a mother with two kids, a grad-school student, a mechanic, a pediatrician. Our conversation stopped in mid-sentence as a MacMillan Bloedel pick-up truck rolled into sight with a scowling man standing like Patton behind the cab. Police cars, buses and huge logging trucks with their piggybacked bunks pulled up to the blockade perimeter and loomed behind him. While he read the court injunction against our protest, another employee walked among us with a video camera, scowling and holding the lens up to our faces as if to say, "We've got you now!" People began leaving the road for the perimeter as the RCMP announced that we would be placed under arrest if we did not move. For a moment it seemed that only a few of us would be left, but when the dust settled, more than three hundred people remained on the road...

The RCMP began arresting people and carrying them to the buses. You could walk or go limply passive and be carried. A chant started up and grew to thunder, "The whole world is watching... Shame!" In the cacophony of helicopters, drums, chanting, cameras and urgent loudspeaker announcements about our rights, the tension grew. Margot and I tightened our grip on each other. The police came closer and closer. In front of us, they tried to grab a young, mentally handicapped boy from his mother and he began screaming. Other children, calm up to this point, began to cry. Support people closed in followed by cameras. Margot said, "I won't go if we can't go together." Three officers came to us. I said, "Help us both up and we'll walk," and they did. As we left, I turned and called out, "It was an honour to be here with you on this day," and I meant it.

There were so many of us that the recreation hall in Ucluelet had to be pressed into service as a jail. When we walked in at about 10:00 a.m. the first bus-load stood and cheered, as we all did for the next bus and the bus after that. When everyone was assembled we held hands in a circle around other circles, sang our songs and ended, with very 60s warmth, in a mass hug. The RCMP charged us, photographed us and required us to sign guarantees that we would not block the road again. Around 6:30 p.m. we were released until our court date in Victoria on August 12th. Although swamped by the largest protest arrest in Canadian history, the police remained courteous and professional. As someone said about this very civil disobedience, "Only in Canada." When we left, Sam was waiting with our car. That night the Clayoquot protest was the lead story across the country without a window being broken or a shot fired.

—1997

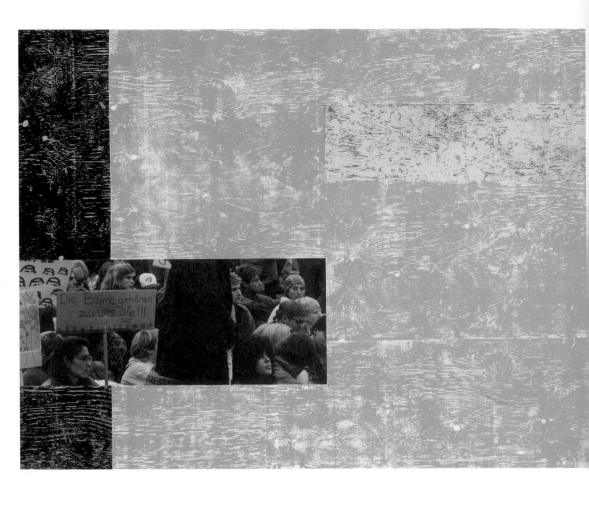

above: **Ian Wallace** | Clayoquot Protest (August 9, 1993) III, 1993–95
facing: **Ian Wallace** | Clayoquot Protest (August 9, 1993) II, 1993–95

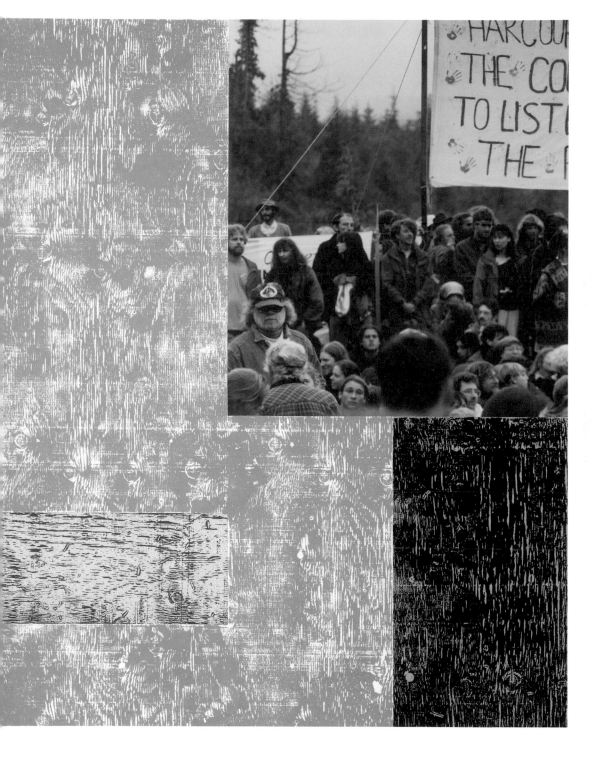

LANDSCAPE

MANUAL

J. WALL

25¢

ARTIST **Jeff Wall**

AUTHOR Jeff Wall

facing: **Jeff Wall** | Landscape Manual, 1970

Jeff Wall | About Making Landscapes (excerpt)

To me, then, landscape as a genre is involved with making visible the distances we must maintain between ourselves in order that we may recognize each other for what, under constantly varying conditions, we appear to be. It is only at a certain distance (and from a certain angle) that we can recognize the character of the communal life of the individual—or the communal reality of those who appear so convincingly under other conditions to be individuals.

—1995

above: **Jeff Wall** | River Road, 1994
overleaf: **Jeff Wall** | The Pine on the Corner, 1990

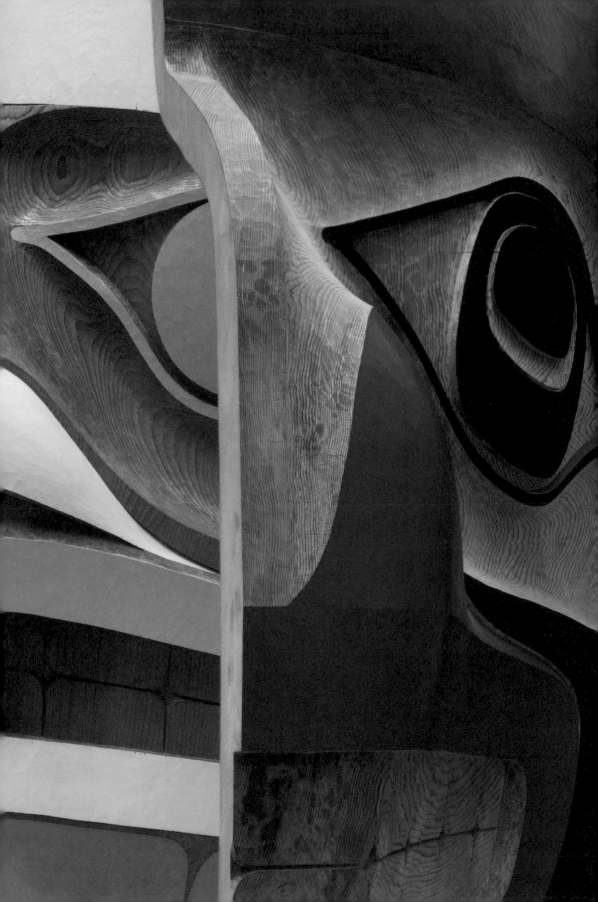

ARTIST **Robert Davidson**

AUTHOR Bill Reid

Bill Reid | Out of the Silence (excerpt)

In each village were great houses
some seventy feet by fifty feet
of clear roof span,
with gracefully fluted posts and beams.
In the houses there was wealth—
not gold or precious stones—
but treasures that only great traditions,
talent, and sometimes genius,
with unlimited time and devotion,
can create.

There were treasures in profusion—
thousands of masks,
painted and carved chests,
rattles, dishes, utensils of all kinds,
ceremonial regalia—
all carefully stored or proudly displayed
during the great feasts and winter ceremonies.

The people of the Northwest Coast
were rich,
their sea even richer;
they were enormously energetic,
and they centred their society
around what was to them
the essence of life:
what we now call "art."

—1970–71

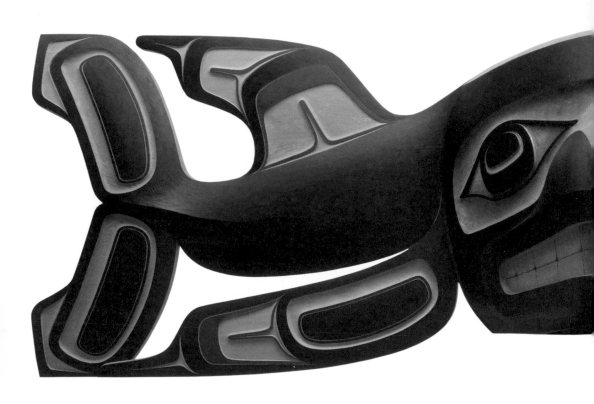

Robert Davidson | Killer Whale
Transforming into a Thunderbird, 2009

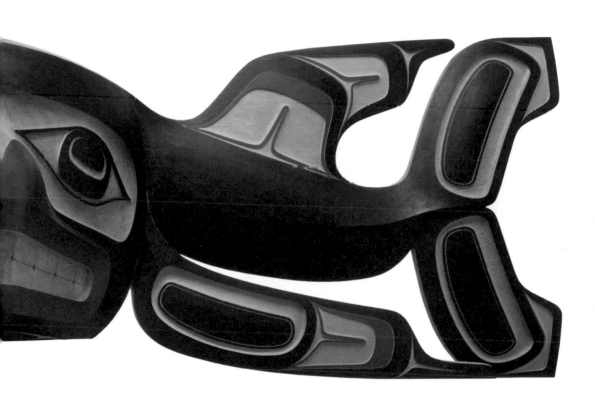

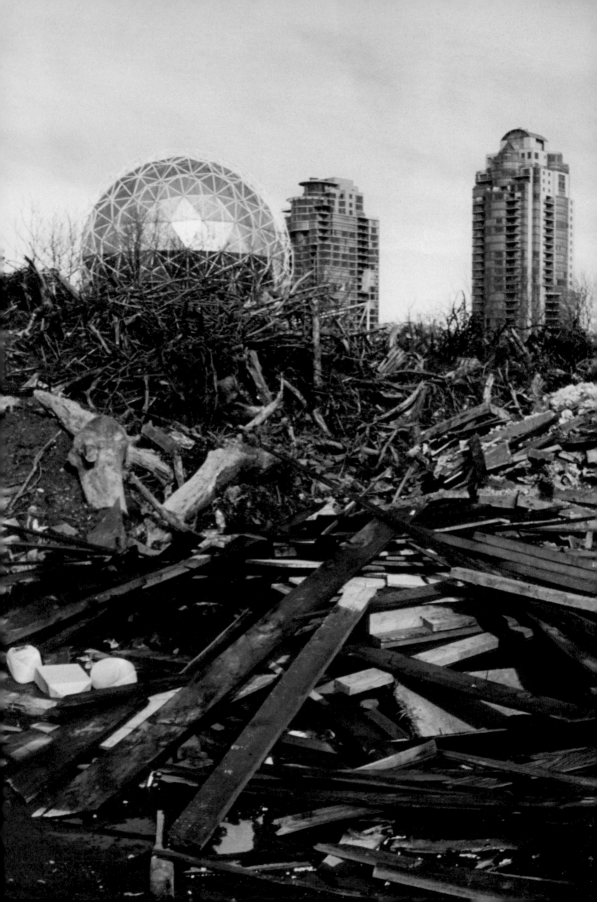

ARTIST **Christos Dikeakos**
AUTHOR Terry Glavin

facing: **Christos Dikeakos** | **Hobo flats—**
s<u>k</u>wácháy's, "**hole in bottom**," 1993 (detail)

Terry Glavin | A Ghost in the Water (excerpt)

It is known in the scientific literature as *Acipenser transmontanus*, a giant freshwater creature that emerged in the Upper Cretaceous period of the Mesozoic era and somehow survived the great extinctions of the ages. It is the largest freshwater fish in North America. It is known locally as the Fraser River white sturgeon...

Throughout this century, the human population has grown by the hundreds of thousands throughout the Fraser Valley. They commute in and out of Abbotsford and Chilliwack and Langley and New Westminster and Vancouver, from the suburbs of Sumas and South Surrey and Deroche and Maple Ridge. There are hundreds of thousands of gallons of sewage and industrial waste pumped into the Fraser River every day. In its last 100 miles, after pouring out of the canyon above Hope, the river has been channelled, diked, dredged and buried over. Still, every so often these 1,000-pound monsters turn up, living dinosaurs that emerged just this side of the Jurassic period 98 million years ago and stopped evolving about two million years ago. Every so often, they still emerge from the muddy depths of the Fraser River, where they have been spending their lives sucking up dead fish and anything else that rolls along the river bottom through an appendage that serves as a mouth but looks more like the severed stub of an elephant's trunk. They get trapped in somebody's net, or on somebody's hook, or crushed

between the logs in a log boom, and the few witnesses to these events are briefly reminded of a long-forgotten beast that still exists below the bridges they commute across every day. A fish that looks like a cross between an antediluvian shark and a giant catfish, half blind . . . It can engage its body in a bizarre process that has excited the attention of neurologists studying phenomena related to comas in human beings—the sturgeon has the capacity to enter into a state of suspended animation so pronounced that it is not unlike death, willed upon itself, and from which it can emerge at will . . .

There were old Sto:lo sturgeon fishermen who said that people who fell from their canoes and whose bodies were never found became sturgeon, or lived among the sturgeon. The memory of these stories is fading, but what's sure is that the white sturgeon are somehow involved in the whereabouts of the souls of those who drown and whose bodies are never recovered from the river.

—1994

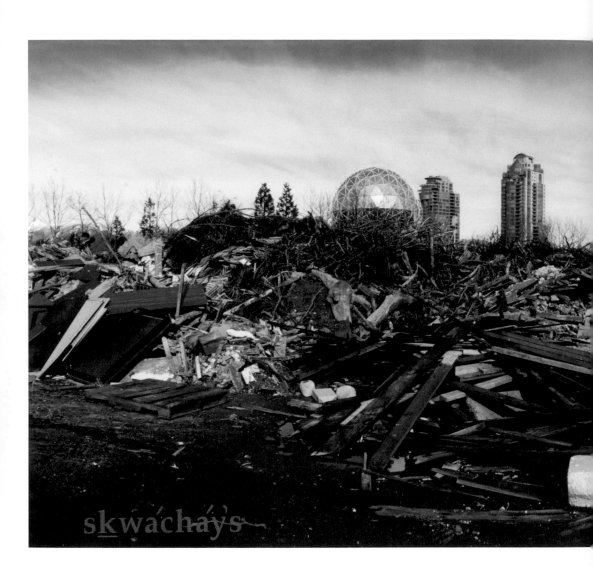

Christos Dikeakos | Hobo flats—
sk̲wáchay̓'s, "hole in bottom," 1993

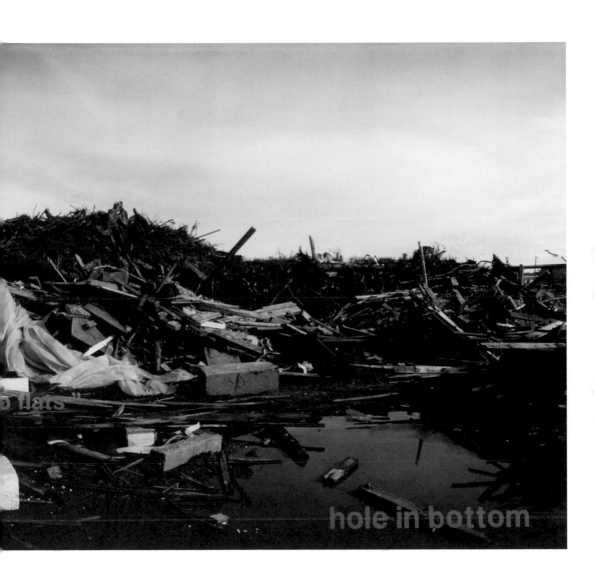

ARTIST **Liz Magor**

AUTHOR **M. Wylie Blanchet**

facing: **Liz Magor** | selected work
from **Deep Woods Portfolio**, 1999 (detail)

M. Wylie Blanchet | The Curve of Time (excerpt)

The first time we met Mike must have been the very first time we anchored in Melanie Cove... He was dressed in the usual logger's outfit—heavy grey woollen undershirt above, heavy black trousers tucked into high leather boots. As I looked at him when he came closer, Don Quixote came to mind at once. High pointed forehead and mild blue eyes, a fine long nose that wandered down his face, and a regular Don Quixote moustache that drooped down at the ends. When he pulled alongside we could see the cruel scar that cut in a straight line from the bridge of his nose—down the nose inside the flare of the right nostril, and down to the lip.

"Well, well, well," said the old man—putting his open hand over his face just below the eyes, and drawing it down over his nose and mouth, closing it off the end of his chin—a gesture I got to know so well in the summers to come...

He wouldn't come aboard, but he asked us to come ashore after supper... We...rounded a small sheltering island, and there, almost out of sight up the bank, stood a little cabin—covered with honeysuckle and surrounded by flowers and apple trees. We walked with him along the paths, underneath the overhanging apple branches. He seemed to know just when each tree had been planted, and I gathered that it had been a slow process over the long years he had lived there...

Down at the far end, where terraces were not necessary, the trees marched up the hillside in rows to where the eight-foot sapling fence sur-rounded the whole place. "The deer jump anything lower," said Mike, when I commented on the amount of time and work it must have taken. Then he added, "Time doesn't mean anything to me. I just work along with nature, and in time it is finished."

Mike sent the children off to gather windfalls—all they could find—while he showed me his cabin. There was a bookshelf full of books across one end of the main room, and an old leather chair. A muddle of stove, dishpans and pots at the other end, and a table . . .

During the next couple of days I spent a lot of time talking to old Mike . . . I gradually heard the story of some of his past, and how he first came to Melanie Cove. He had been born back in Michigan in the States. After very little schooling he had left school to go to work. When he was big enough he had worked in the Michigan woods as a logger—a hard, rough life. I don't know when, or how, he happened to come to British Columbia. But here again, he had worked up the coast as a logger.

"We were a wild, bad crowd," mused Mike—looking back at his old life, a faraway look in his blue eyes. Then he told of the fight he had had with another logger.

"He was out to get me . . . I didn't have much chance."

The fellow had left him for dead, lying in a pool of his own blood. Mike wasn't sure how long he had lain there—out cold. But the blood-soaked mattress had been all fly-blown when he came to.

"So it must have been quite some few days."

He had dragged himself over to a pail of water in the corner of the shack and drunk the whole pailful . . . then lapsed back into unconsciousness. Lying there by himself—slowly recovering.

"I decided then," said Mike, "that if that was all there was to life, it wasn't worth living; and I was going off somewhere by myself to think it out."

So he had bought or probably pre-empted wild little Melanie Cove—isolated by 7,000-foot mountains to the north and east, and only accessible by boat. Well, he hadn't wanted neighbours, and everything else he needed was there. Some good alder bottom-land and a stream, and a sheltered harbour. And best of all to a logger, the southeast side of the cove rose steeply, to perhaps eight hundred feet, and was covered with virgin timber. So there, off Desolation Sound, Mike had built himself a cabin, handlogged and sold his timber—and thought about life . . .

—1961

Liz Magor | selected works from **Deep Woods Portfolio**, 1999

ARTIST **Rodney Graham**

AUTHOR Timothy Taylor

facing: **Rodney Graham** | selected work
from **75 Polaroids**, 1976 (detail)

Timothy Taylor | Stanley Park (excerpt)

When he found his father, they stood for a moment and looked at each other. Jeremy's favourite cowboy boots were past wet, the branches now reaching to soak his back and neck.

"Is this it?" he said. Through the trees Jeremy could make out campfires spread in the darkness around them.

"Not quite yet," the Professor said, motioning with his head that they should continue. He turned and hoisted a leg up to a foothold on a large root-covered rock, gripped the gnarled wood with his fingertips and disappeared over the top.

It was the root end of a gigantic tree, Jeremy realized. Torn from the soil by a gust of wind, torn up along with the huge boulder to which the roots had been clinging. Jeremy climbed inexpertly after his father and stood at the base of the broad trunk. It stretched out in front of them like a bridge, 150 feet long, silver in the moonlight. As they walked it bowed slightly beneath them. It surprised Jeremy, this slight bending of the massive trunk. He would have thought their weight was not enough to move such a great thing, a thing that vaulted them through the brush to a completely different part of the park. A denser part. A place that had no relation to anything that he had previously known.

"What we want is a fire," the Professor said from ahead of him, as they descended a slope.

And he lit good fires too, Jeremy discovered. After half an hour tramping through the damp and the dark, the Professor made a small hot fire in

just a few minutes. Built with few words spoken, in a trench at the centre of his camp.

While the Professor changed into dry clothes, Jeremy squatted back-assed to the heat and considered that if he were abandoned here, he would be lost until morning. Perhaps even then. So busy a park, thousands of visitors a day. Never once had he felt lost in it, as he was now.

A map and a global positioning system would have revealed to him that he was not far from things that he knew. Just a couple of hundred yards off the Park Drive, near Prospect Point, in fact. Here a densely forested slope fell from the road, down to the top of a cliff that towered a hundred feet above the seawall and the ocean below. The Professor had found a clearing between the trees at the very edge of this cliff. There were tamped-down ferns and a tent built against the trunk of a cedar, a space big enough for one very still, very accomplished sleeper. And through the branches of this tree, and the others that umbrella-ed over the small clearing, one had a view of the harbour, freighters silent at their moorage, well lit. At the bottom of the cliffs and to the left stood Siwash Rock, which pillared fifty feet out of the water near the shore. A rock that was once a bather, legend had it, a bather honoured by the gods with this permanent place at the lip of forest that had been his home.

The Professor plucked the canvasback and drew it smoothly. He buried the entrails some distance away. He washed his hands and the bird with water from a plastic juice container. "Did you bring any salt by any chance?" he asked, returning to the fire. "No matter, I have a packet left."

"How about string?" Jeremy asked. You might as well do it right, he thought. And when the Professor produced his string, Jeremy trussed the bird, tying it into the fork of a blackened Y-shaped stick. He buried the other end of the stick in the soft earth, supported it across a large stone and cantilevered the bird above the flames. By sliding the stone back and forth, the bird's height and roasting temperature could be very roughly adjusted. He sat back in the dry area of fern nearest the flames and folded his arms across is knees.

There was silence for some time. The bird began to glisten, then hiss gently. Finally the aroma was released: smoky, fatty, rich with oil. He twisted the stick a quarter turn.

"This is all quite illegal, of course," Jeremy said finally, aware that the comment was softened by his own complicity. But the Professor only looked at him as if he were a little slow for just getting this point. "All right," Jeremy went on, failing to resist a small smile. The duck smelled good. "How do you catch a starling?"

—2001

facing: **Rodney Graham** |
selected works from 75 **Polaroids**, 1976

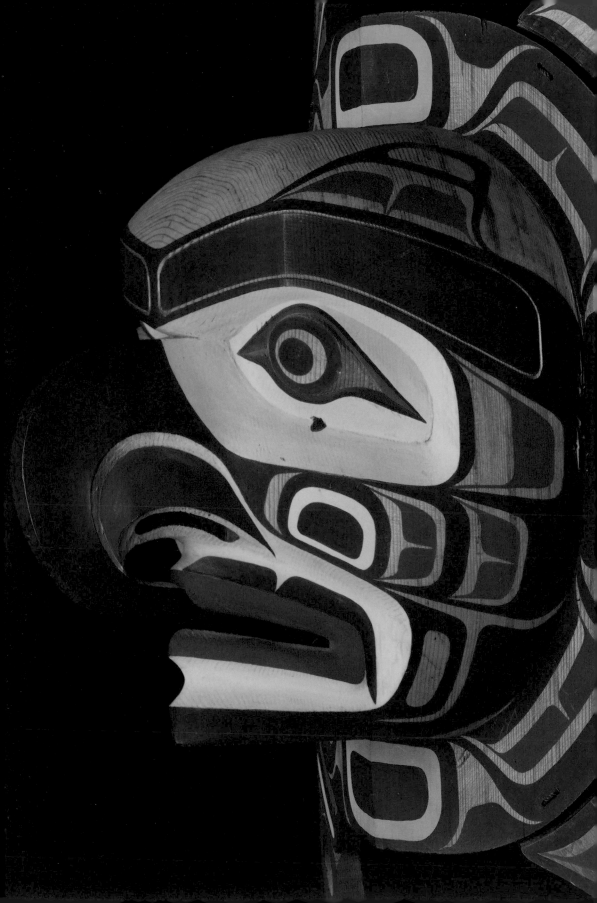

ARTIST **Richard Hunt**

SOURCE Kwakwaka'wakw
tradition

Mink and the Sun (excerpt)

There was a woman named Mother...She was always making mats. She was sitting down making a mat, and many clouds were in our sky. Sometimes the sun would shine through the clouds, and then he shone through the roof of Mother's house; and suddenly he shone on the small of the back of Mother. In this way she became pregnant. Immediately she ceased making mats, for she thought she might hurt her child. When she had been with child for a long time, she gave birth to a boy. Mother named him at once Born-to-be-the-Sun, for she knew that the Sun had made her pregnant...

Born-to-be-the-Sun arose and went out of his house. He carried his bow and his arrows. Then he called to his mother to follow him. As soon as she was outside of the house, he strung his bow, and Born-to-be-the-Sun shot [his arrow] against the upper world. Then he shot another arrow, and still another one, and yet another. Now he had shot all the four arrows.

Born-to-be-the-Sun had not looked up long when the arrows came sticking one into the other and struck the ground. They began to stretch out. Then Born-to-be-the-Sun took them and shook them, and they became a rope. Then Born-to-be-the-Sun spoke to his mother, and said, "O mother! as soon as this rope stops shaking, pull at it." Born-to-be-the-Sun wished to go to the upper world because he had had a quarrel with the children. They had said that he had no father. Therefore he went crying to his house, and told his mother of what the children had said. Then his mother said, "O child! the little children do not know that Walking-through-the-Heavens, Walker-of-the-World, Looked-upon-by-the-World, is your father." Thus said Mother to Born-to-be-the-Sun, and that is the reason [the place where] he said that he would go up.

Then Born-to-be-the-Sun climbed up the rope; and Mother held the end of the rope, so that it could not shake while her child was climbing up. Then Born-to-be-the-Sun reached the hole [in the sky]. As soon as Born-to-be-the-Sun had gone through what is called the door of the upper world, he saw a house. Then he started and went to sit down outside. He had not been there very long when a woman came out of the house of Walking-through-the-Heavens. As soon as she saw Born-to-be-the-Sun, she spoke, and said, "Oh, little one! Where do you come from, sonny?" Thus she said to him. Then Born-to-be-the-Sun also spoke, and said, "I came to see my father here, Walking-through-the-Heavens." Thus he said. Immediately the woman went back into the house.

Then she told Walking-through-the-Heavens [about it], and said, "O chief, Walking-through-the-heavens! a child has come, and sits outside our house. He says that he has come to see his father, you, chief." Thus she said. The chief spoke at once, and said, "Oh, it is true, I got him by shining through his mother. Go and call him to come into our house." Thus said Walking-through-the-Heavens. The woman went out again to call him, and Born-to-be-the-Sun came and sat down in the house. Then the chief, Walking-through-the-Heavens, spoke, and said, "Welcome, child! for I am getting too weak to go always from one end of the world to the other. Now you shall change places with me, child." Thus said Walking-through-the-Heavens to Born-to-be-the-Sun.

Then Walking-through-the-Heavens asked that Born-to-be-the-Sun should be fed. Walking-through-the-Heavens was tired, therefore he did not walk that day; for that is the time for Walking-through-the-Heavens to take a rest, when there are many clouds in the sky. After Born-to-be-the-Sun had eaten, the chief spoke again, and said, "O child! take care! dress yourself up in my ornaments this evening, and try to walk in the morning, and don't walk too fast; and do not sweep away your aunts the clouds too quickly, else it will go hard with the tribes of our lower world." Thus he said, and took his ear-ornaments of abalone-shell and put them on the ears of Born-to-be-the-Sun. Then Born-to-be-the-Sun was dressed up.

In the morning, when day came, Born-to-be-the-Sun was sent to go and walk . . . Born-to-be-the-Sun started, and he obeyed the word of

Walking-through-the-Heavens. He was walking along quite nicely. When it was nearly noon, he grew tired. Then Born-to-be-the-Sun spoke as he was walking along, and said, "Confound it! Get away! You get in my way too much." Thus he said, and swept away the clouds. Then he began to run.

Then our world became hot, and then cracks began to appear [to split] in the mountains, and therefore also the surface of the rocks of the whole world was burnt. Walking-through-the-Heavens spoke at once, and said, "Go and follow him who is not wise, for evidently he is running fast. Take away his ear-ornaments at once, and throw him down." Thus said the chief to one of his men. Then the man went after him and caught up with him. At once he took away his ear-ornaments and his abalone-shells. Then Born-to-be-the-Sun was thrown out of the other door of the upper world.

Born-to-be-the-Sun had made a mistake, for the sea was almost boiling, and the tribes in this lower world were nearly dead. This is the reason why the tops of the yellow-cedar trees are dead, and this was the cause of Walking-through-the-Heaven's anger towards Born-to-be-the-Sun. He was thrown down by the man. Some people say that Walking-through-the Heavens threw Born-to-be-the-Sun down.

Four women had gone out to dig clams. Then the women discovered something floating among the drifting seaweed. One of them said, "Let us go to the thing that I have found there drifting." Thus she said. As soon as they went towards it, they recognized Born-to-be-the-Sun; and they said, "This is our chief, Born-to-be-the-Sun." The women wished to take him into the canoe; but he awoke and began to spit. He said, "I have been sleeping on the water for a long time." Then he swam ashore, and went to his house.

Mother spoke at once, and said, "O child! don't wish again to go to your father. You have almost killed our tribe [thus said Mother to him], for you do not know how to handle the mask of your father." Thus she said. That is the end.

—Kwakwaka'wakw tradition, transcribed by Franz Boas, 1905

facing: **Richard Hunt** | Mask Representing the Ancestral Sun, 1978

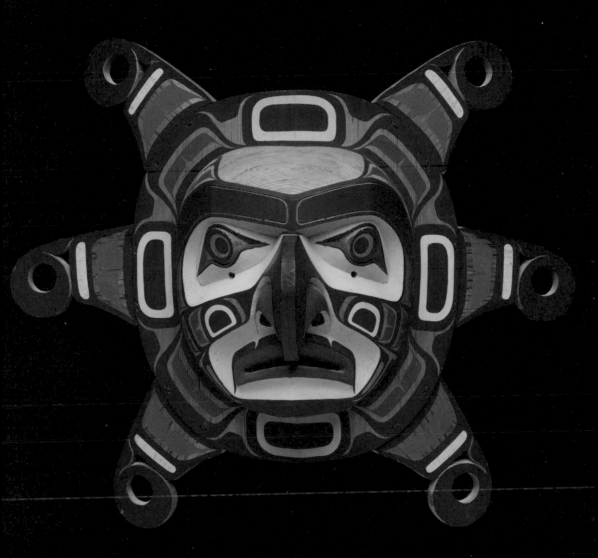

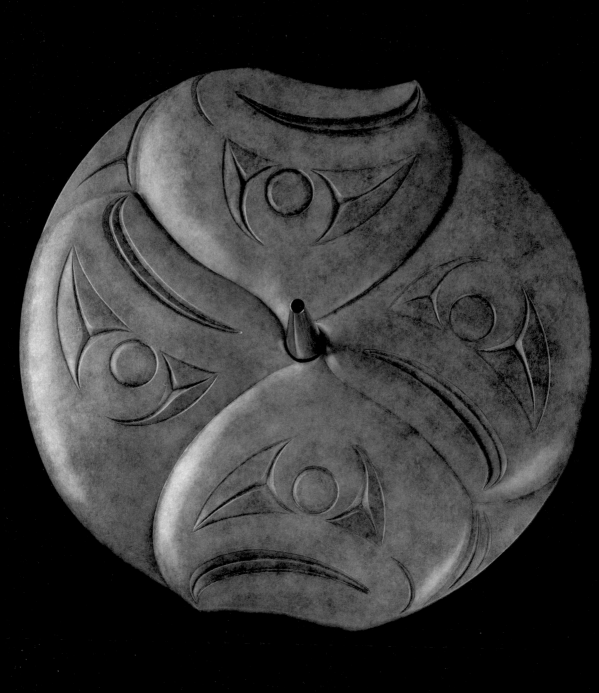

ARTIST **Susan Point**

AUTHOR Daphne Marlatt

facing: **Susan Point** | Salmon Gathering, 2000

Daphne Marlatt | generation, generations at the mouth

clans of salmon, chinook, coho, gathering just off shore, backbones no longer intact, steam-pressured in millions of cans, picked clean barbecue leavings in a thousand garbage bags ripped open by cats, rats, they can't find their way back

what is the body's blueprint?

return what is solid to the water, the first peoples said—
returned, every bone intact
generates the giving back of race, kind, kin

choked in urban outfalls, fished as they aim for rivers sediment-thick with run-off, *tamahnous* of the wild they hover, sonar streaks, impossible vision-glitches, outside pens where farmed lookalikes grow pale & drugged

kin, wild skin, wild & electric at the mouth where rivers disappear in the that that is not that, the chinook can't find their way back

come out of the blue: this flow, these energy rivers & wheels, radiant giving unlocked. & not this frozen, this canned product eagles once stripped, eagles, bears going, gone, hungry & wild outside shut doors where light pools & we pore over stock market news, refuse, refuse our interrelation, refuse to pour back

what is the body's blueprint? impermanent, shifting energy blocks in its own becoming, a stream & streaming out to the void where rivers lose themselves

in the bardo as many beings as waves gather at any opening, those in-between and not-yet ones that race a river of sperm to be here now, light-pour, each cell in its dying turn returns

what is the mouth of the river now? a toxic O of emptiness? teeming hole of ever-becoming we create? re-entry. re-turn. verbing the noun out of its stuck edges and into occurrence, currents, curre-...we've lost the verb in our currency, a frozen exchange streaming emptiness

 (they're fishing in London now)

at the mouth of the river, clans of the possible are gathering, the chinook, the coho rivering just offshore are us

 —2000

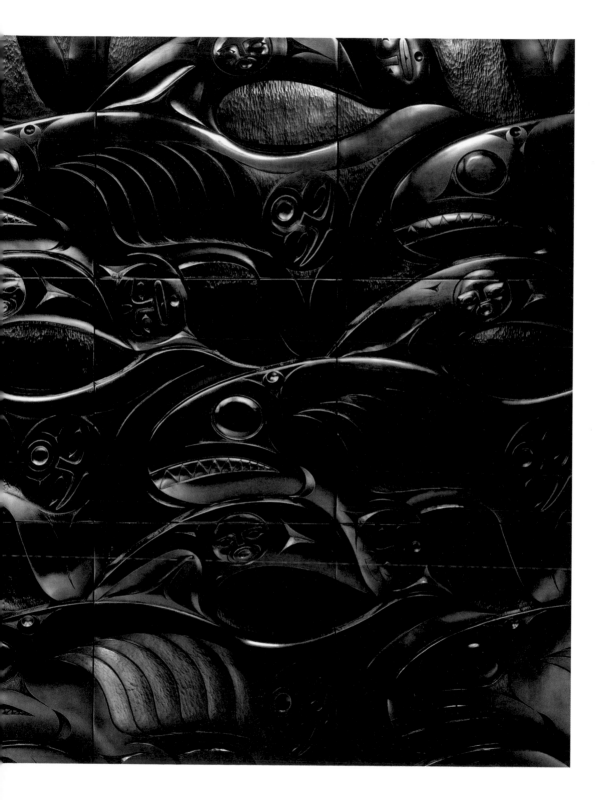

ARTIST **Michael Nicoll Yahgulanaas**

AUTHOR **'Laana awga Chief Sgiidagiids**

'Laana awga Chief Sg̲iidagiids

People are like trees, and groups of people are like forests.

While the forests are composed of many different kinds of trees
these trees intertwine their roots so strongly that it is impossible for the
 strongest winds
which blow on our islands to uproot the forest.

For each tree strengthens its neighbour,
and their roots are inextricably intertwined.

In the same way the people of our islands
composed of members of nations and races from all over the world
are beginning to intertwine their roots so strongly that no troubles will
 affect them.

Just as one tree standing alone would soon be destroyed by the first strong
 wind which came along so is it impossible for any person, any family,
 or any community to stand alone against the troubles of this world.

—c. 1970

Michael Nicoll Yahgulanaas | Red, 2008–9

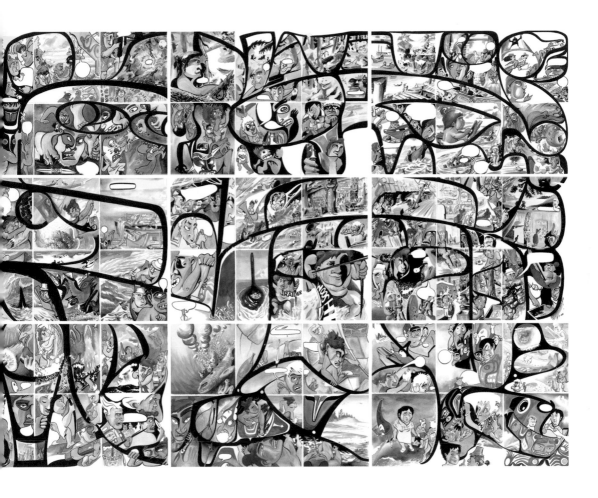

161

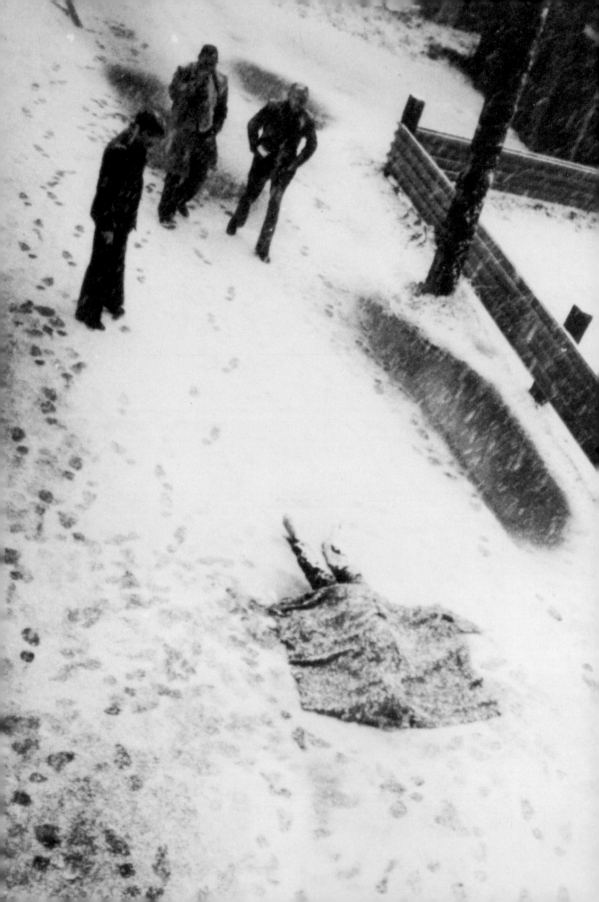

ARTIST **Paul Wong**

AUTHOR Joseph Ferone

facing: **Paul Wong with Kenneth Fletcher** |
selected work from **Murder Research**, 1977 (detail)

Joseph Ferone | BC Collateral

The bus stopped
before the pawnshop window:
I went to the guitars,
you went to the knives.

—2009

facing: **Paul Wong with Kenneth Fletcher** |
selected works from **Murder Research**, 1977

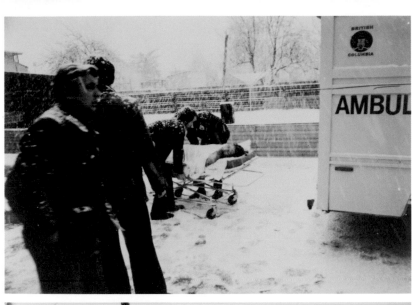

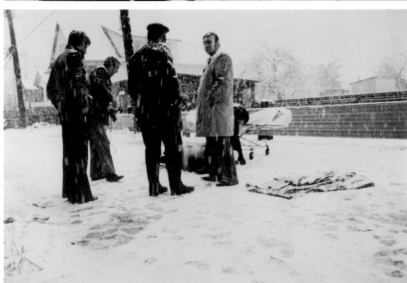

ARTIST **Ken Lum**

AUTHOR Madeleine Thien

Madeleine Thien | Simple Recipes (excerpt)

There is a simple recipe for making rice. My father taught it to me when I was a child. Back then, I used to sit up on the kitchen counter watching him, how he sifted the grains in his hands, sure and quick, removing pieces of dirt or sand, tiny imperfections. He swirled his hands through the water and it turned cloudy. When he scrubbed the grains clean, the sound was as big as a field of insects. Over and over, my father rinsed the rice, drained the water, then filled the pot again.

The instructions are simple. Once the washing is done, you measure the water this way—by resting the tip of your index finger on the surface of the rice. The water should reach the bend of your first knuckle. My father did not need instructions or measuring cups. He closed his eyes and felt for the waterline.

Sometimes I still dream my father, his bare feet flat against the floor, standing in the middle of the kitchen. He wears old buttoned shirts and faded sweatpants drawn at the waist. Surrounded by the gloss of the kitchen counters, the sharp angles of the stove, the fridge, the shiny sink, he looks out of place. This memory of him is so strong, sometimes it stuns me, the detail with which I can see it.

Every night before dinner, my father would perform this ritual—rinsing and draining, then setting the pot in the cooker. When I was older, he passed this task on to me but I never did it with the same care. I went through the motions, splashing the water around, jabbing my finger down to measure

the water level. Some nights the rice was a mushy gruel. I worried that
I could not do so simple a task right. "Sorry," I would say to the table, my
voice soft and embarrassed. In answer, my father would keep eating,
pushing the rice into his mouth as if he never expected anything different,
as if he noticed no difference between what he did so well and I so poorly.
He would eat every last mouthful, his chopsticks walking quickly across the
plate. Then he would rise, whistling, and clear the table, every motion so
clean and sure, I would be convinced by him that all was well in the world.

—2001

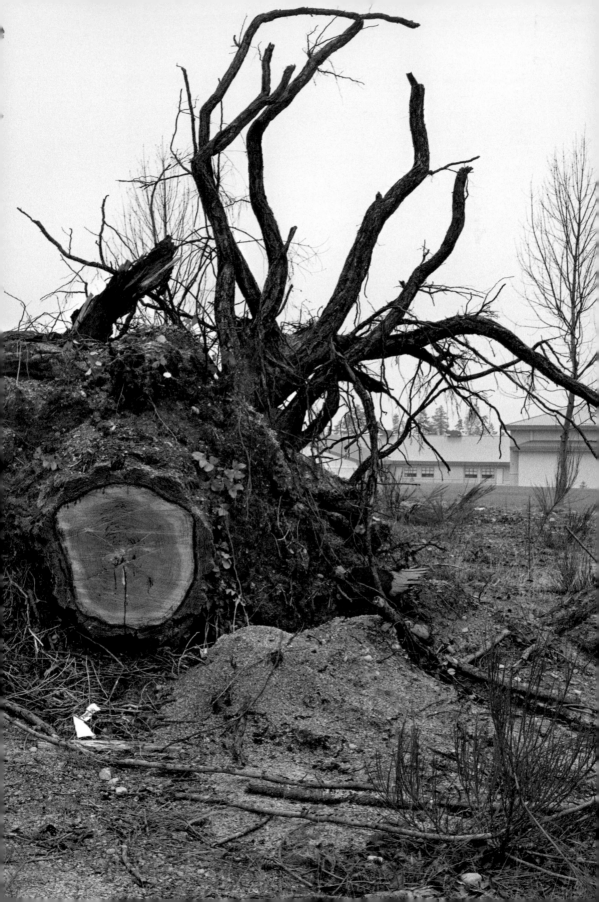

ARTIST **Roy Arden**

AUTHOR David Pitt-Brooke

facing: **Roy Arden** | **Tree Stump, Nanaimo, B.C.**, 1991 (detail)

David Pitt-Brooke | Chasing Clayoquot (excerpt)

There is a strength that flows from undisturbed countryside, something
that resonates in us, some sort of rhythm, a sense of rightness, perhaps.
Always on these little journeys I am conscious of coming into tune with the
natural world, of reawakening something that brings me energy and joy, as
if the tide had turned in my favour. We are sustained in a real way by pris-
tine wilderness. These are the landscapes of hopes and dreams, of endless
possibility. When we destroy them, we cut ourselves off from a source of
nourishment and strength. We are diminished. Wretched country begets
wretched people. Ancient forests are part of the essence of life on the west
coast of Vancouver Island. We are a rainforest people, native or naturalized,
by birth or by choice. These forests help to shape our sense of a shared iden-
tity; of our own place in the world. What will become of us when they are
gone? We will become a people of strip malls, I suppose, and big-box retail
outlets, and multi-lane highways to nowhere worth going.

—2004

above: **Roy Arden** | Plywood Stacks, Vancouver, B.C., 1991
overleaf: **Roy Arden** | Construction Site and "Suntower," Vancouver, B.C., 1992

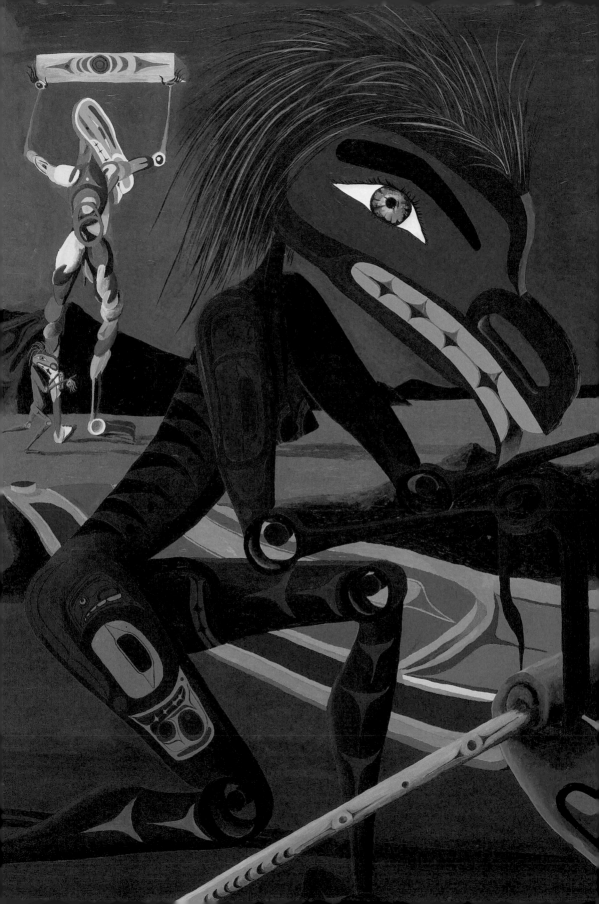

ARTIST Lawrence Paul Yuxweluptun

AUTHOR Ronald Wright

facing: **Lawrence Paul Yuxweluptun** | Guardian Spirits
on the Land: Ceremony of Sovereignty, 2000 (detail)

Ronald Wright | Stolen Continents (excerpt)

When the Anglo-Saxon and the Iberian came to the New World, each remained true to his traditions. The Spanish soldier of fortune wanted gold and serfs so that he could live the idle, domineering life. The English peasant wanted land, and to get it he did again what his forebears had done to the forebears of the Welsh. That history happened. It cannot be undone. In much of the Americas, Indians are indeed "too few to fight." The Delawares are gone from Delaware, the Massachusetts from Massachusetts. There are no Ottawas in Ottawa, nor Manhattans in Manhattan. A name on the map is often the only tombstone of a murdered people. In many places, from Newfoundland to Patagonia, even the names are dead. But as the voices that speak in this book make clear, there are also millions who survive. To ignore their existence and their wishes is to become accessories to murder. They are too many to die...

The past cannot be changed, but what we make of it certainly can. The new nations of America will never take root in its soil until they confront what is hidden by their myths and make reparation to the survivors of the holocaust that began five centuries ago. They could start by admitting what they have done. They could start by honoring their own treaties; by ceasing to put dams, mines, and chemical dumps on the little territory the first nations have left. They could start by teaching the other side of their history—the dark side—in their schools.

The people from the "Old World" cannot go back across the sea, nor should they. And the mixed people born of both worlds can have no other home. But the intruders and their offspring can at least make room for the American peoples who remain. They can offer true equality, not annihilation disguised as "integration" or *mestizaje*, nor the fictitious liberty of citizenship in Euro-American countries where the Indian will always be outnumbered and outvoted. They can accept the right of American Indians to be free, equal, and different.

The invaders can stop "conquering and discovering." And if they begin to treat America as a home in which to live, not a treasure house to ransack—a home for the first nations as well as for themselves—they may, unlike Christopher Columbus, discover where they are.

—1992

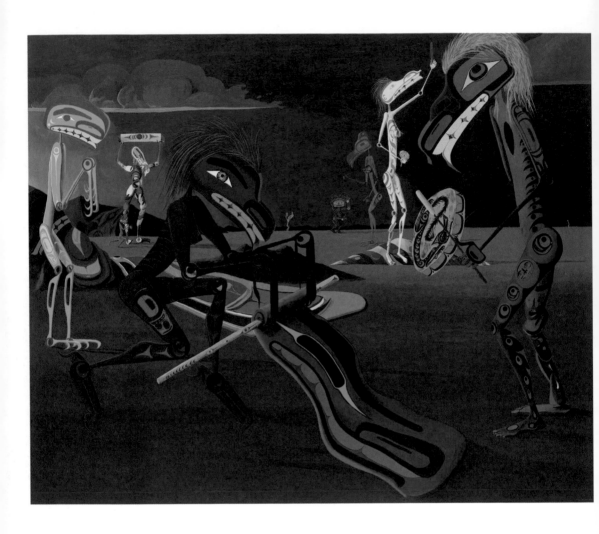

Lawrence Paul Yuxweluptun | Guardian Spirits
on the Land: Ceremony of Sovereignty, 2000

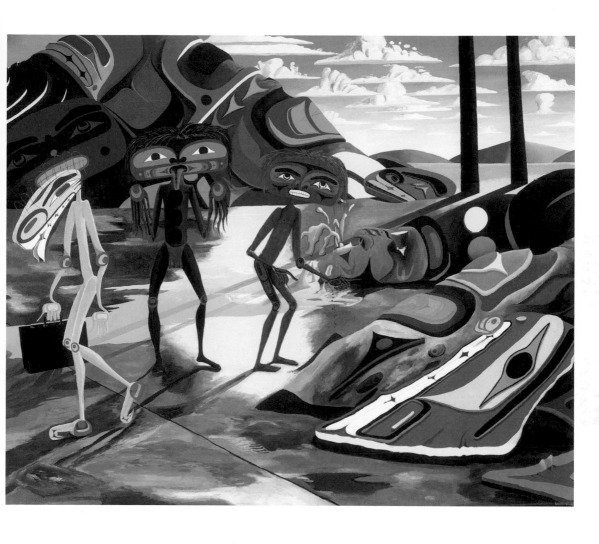

Lawrence Paul Yuxweluptun | The Impending
Nisga'a' Deal. Last Stand. Chump Change, 1996

CLOSING OUT

CLOSING OUT
20% 50%

152

ARTIST **Stan Douglas**
AUTHOR Gregory Scofield

facing: **Stan Douglas** | *Every Building on*
100 West Hastings Street, 2001 (detail)

Gregory Scofield |

How Many White People Noticed (and recounted the scene over dinner)

Outside the Dodson
the scene wasn't as disturbing
as seeing a wino
plunge twelve stories or
hearing the fatal crack
of a human skull
upon impact.
Still, by the way she landed
she must have went down
like a ton of bricks.

At first
I thought she was a goner.
Then I saw
her fingers twitch.
"She's had it, eh?" some drunk said,
wobbling down beside her.
"You her old man?" I asked,
moving in
so he couldn't cop a free feel.

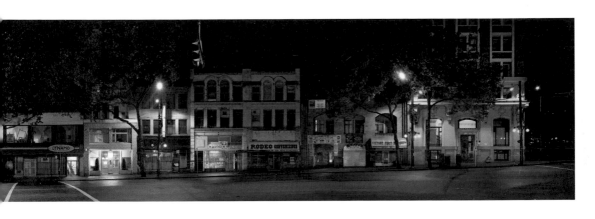

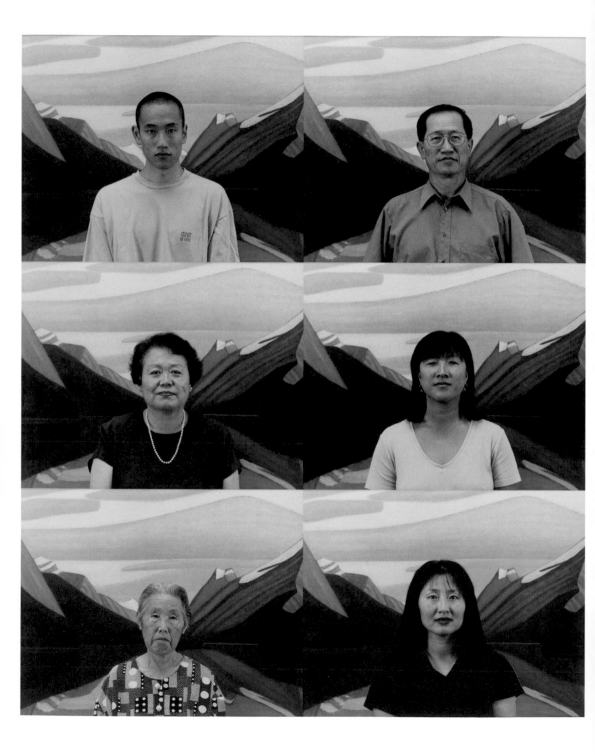

A crowd assembled, mostly drunks
from other boozecans
along 100 block.
9-1-1 said turn her on her side,
clear her mouth, tilt her head back,
talk calmly, wait.
Brushing back her hair I saw
she was in her early twenties.
Her face was smooth
and free of bruises—
I could tell
she didn't put up with any shit.

Finally the paramedics arrived.
Having checked her vital signs
and finding them satisfactory
they shook her so roughly
she opened her eyes.
"How much have you had
to drink today?"
"Hey, how much have you had
to drink today?"
"HOW MUCH HAVE YOU HAD
TO DRINK TODAY?"

Her eyes floated over
and discovered me slowly.
"My boy's in care," she slurred,
grabbing my hand,
"I gotta see my worker."

Across the street
a businessman sat in his car
watching the entire scene.
Only after she was up
and staggering towards Pigeon Park
did he leave, grinning
as smart as
the clatter of china, the clinking
of knives on crystal,
always the knives, I thought
their goddamn knives.

—1996

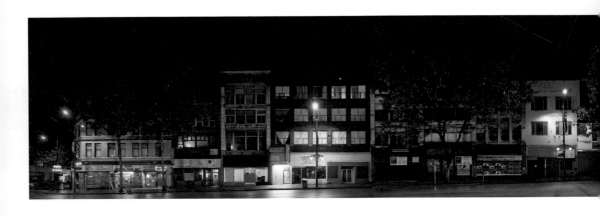

Stan Douglas | Every Building on 100 West Hastings Street, 2001

ARTIST **Jin-me Yoon**
AUTHOR Rita Wong

facing: **Jin-me Yoon** | selected works from
A Group of Sixty-seven, 1996 (detail)

Rita Wong |

for kwong lee taitai, who landed in victoria the year of the monkey, 1860

so much has changed so
little has changed
between you & me:
mobbings
occasional riots
the usual sneers
chinese exclusion act
gold rush
attempts to put us
in separate schools
finally the right to vote in 1947
now head taxes apply
to all immigrants
not just
us

i found you
a merchant's wife
officially romanized
briefly mentioned in
that oppressive newspaper
The Colonist

one of many
silences i want to hear

—1998

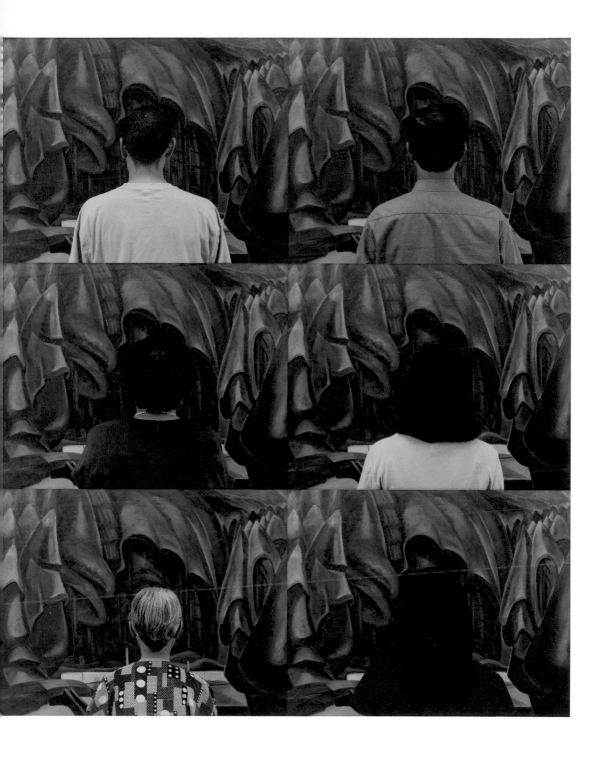

Jin-me Yoon | selected works from **A Group of Sixty-seven**, 1996 (detail) 193

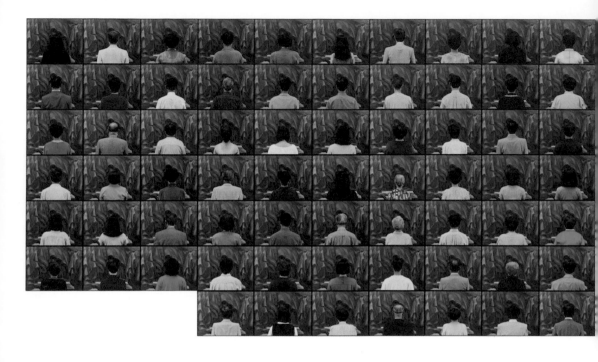

Jin-me Yoon | A Group of Sixty-seven, 1996

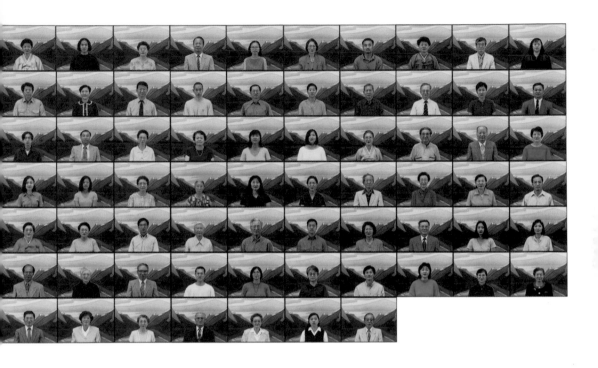

ARTIST **Brian Jungen**

AUTHOR Douglas Coupland

facing: **Brian Jungen** | Cetology, 2002 (detail)

Douglas Coupland | City of Glass (excerpt)

WHALES

A few years ago I was driving downtown when I heard on the radio that a dead grey whale had washed up in English Bay. Without further thought, I drove there to see it. It was mid-afternoon on a glorious Technicolor blue sky day, and already a fair crowd had gathered around what, from a distance, appeared to be a fishing boat or a yacht lying on its side.

Up close the whale's skin was charcoal grey and covered in barnacles like a boat's hull, or like Deck-Kote marine paint. Local marine biologists were there taking samples to try and figure out why the whale had beached itself. From the head they'd cut a square chunk of tissue the size, thickness and shape of a sofa cushion. It was orange and flaky looking, like a tin of canned salmon. In the open mouth, I could see the whale's baleen—the thin fibrous strands it used to filter out larger objects. It looked like a wiry broom, like an antique Japanese comb.

What really struck me was who'd come to see the whale—people who'd been working at their desk or photocopying or having meetings, who'd maybe heard about the whale while in the cafeteria listening to the local news and EZ-listening station, and then suddenly dropped everything and scurried off to see it. Men wore ties; women were dressed in their office clothes. Everybody was scrambling over rocks coated with razor-sharp blue mussels and barnacles. One woman had snagged her pantyhose on a piece of driftwood; another had lost the heel of her shoe; one guy had stepped in a tidal pool and soaked his leather brogue, but I'll bet you a million bucks none of them cared.

—2000

facing: **Brian Jungen** | Prototype for New Understanding #3, 1999

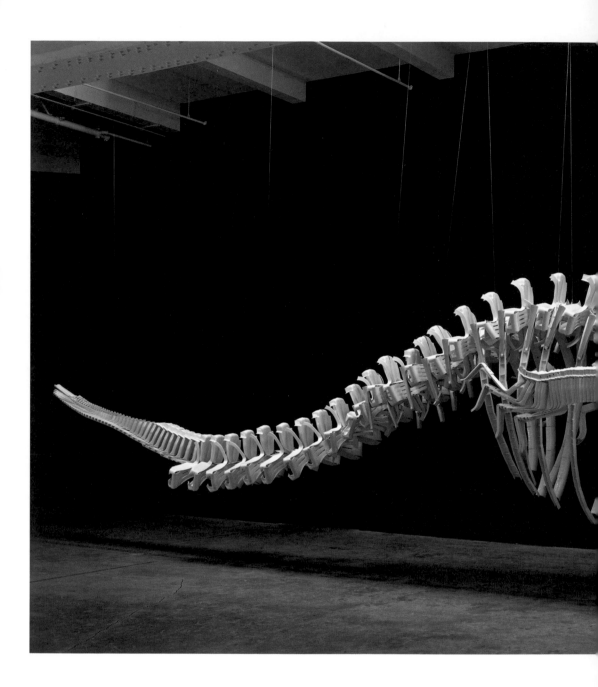

Brian Jungen | Cetology, 2002

ARTIST **Althea Thauberger**
AUTHOR Fred Wah

Fred Wah | How to Hunt

Colour it brown
think about it
ahead of time
think about it
afterwards
listen to you
how alone you are
sitting on a log
in the forest
look at it about to happen
completely in your mind
and the world
all the trees
even the sky
size
surrounds everything
did you remember
did you forget
say it
"sheh"
how heavy the task
I've tracked myself
to this log
nothing else nothing waits
get up (later
you'll get lost.

—1981

Althea Thauberger | not afraid to die, 2001 (stills)

205

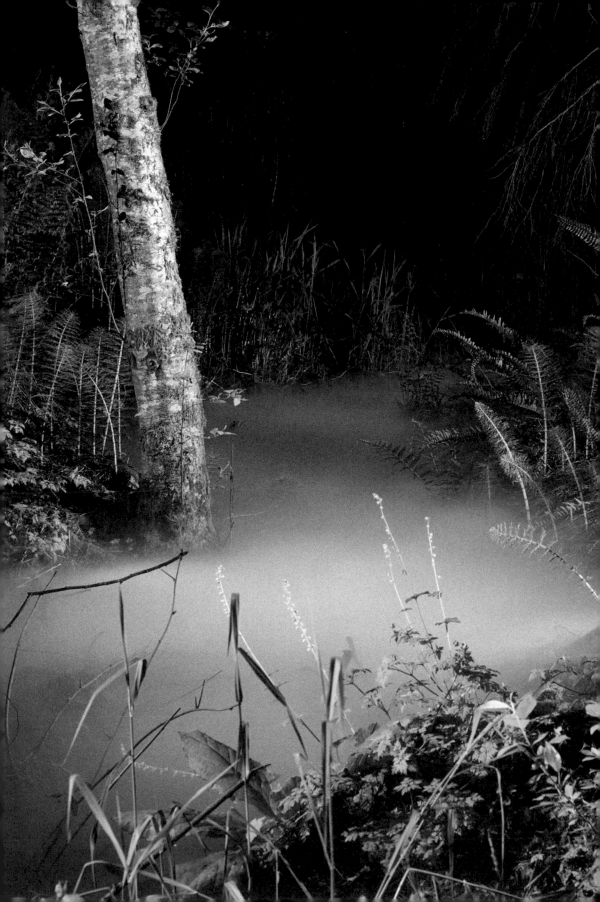

ARTIST **Kevin Schmidt**
AUTHOR Emily Carr

facing: **Kevin Schmidt** | **Fog Study**, 2004 (detail)

Emily Carr | Hundreds and Thousands (excerpt)

NOVEMBER 28, 1935

What most attracts me in those wild, lawless, deep, solitary places? First, nobody goes there. Why? Few have anything to go *for*. The loneliness repels them, the density, the unsafe hidden footing, the dank smells, the great quiet, the mystery, the general mix-up (tangle, growth, what may be hidden there), the insect life. They are repelled by the awful solemnity of the age-old trees, with the wisdom of all their years of growth looking down upon you, making you feel perfectly infinitesimal—their overpowering weight, their groanings and creakings, mutterings and sighings—the rot and decay of the old ones—the toadstools and slugs among the upturned, rotting roots of those that have fallen, reminding one of the perishableness of even those slow-maturing, much-enduring growths. No, to the average woman and to the average man (unless he goes there to kill, to hunt or to destroy the forest for utility) the forest jungle is a closed book. In the abstract people may say they love it but they do not prove it by entering it and breathing its life. They stay outside and talk about its beauty. This is bad for them but it is good for the few who do enter because the holiness and quiet is unbroken.

Sheep and other creatures have made a few trails. It will be best to stick to those. The sallal is tough and stubborn, rose and blackberry thorny. There are the fallen logs and mossy stumps, the thousand varieties of growth and shapes and obstacles, the dips and hollows, hillocks and mounds, riverbeds,

forests of young pines and spruce piercing up through the tangle to get to the quiet light diluted through the overhanging branches of great overtopping trees. Should you sit down, the great, dry, green sea would sweep over and engulf you. If you called out, a thousand echoes would mock back. If you wrestle with the growth it will strike back. If you listen it will talk, if you jabber it will shut up tight, stay inside itself. If you let yourself get "creepy," creepy you can be.

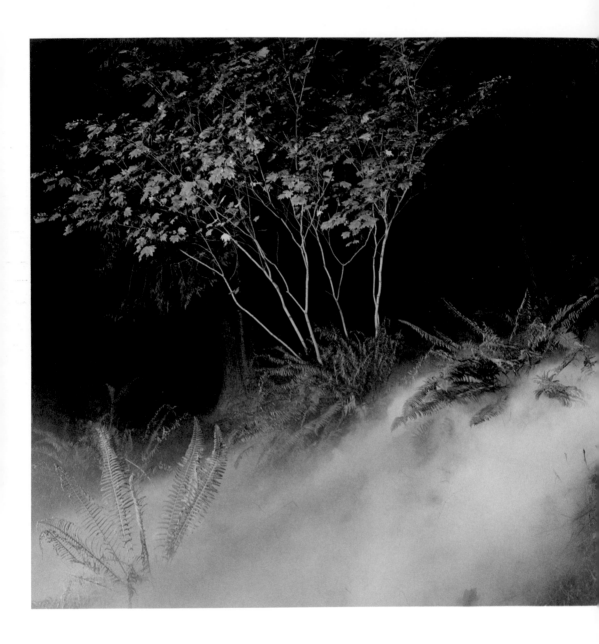

Kevin Schmidt | Fog Study, 2004

Kevin Schmidt | Fog Study, 2004

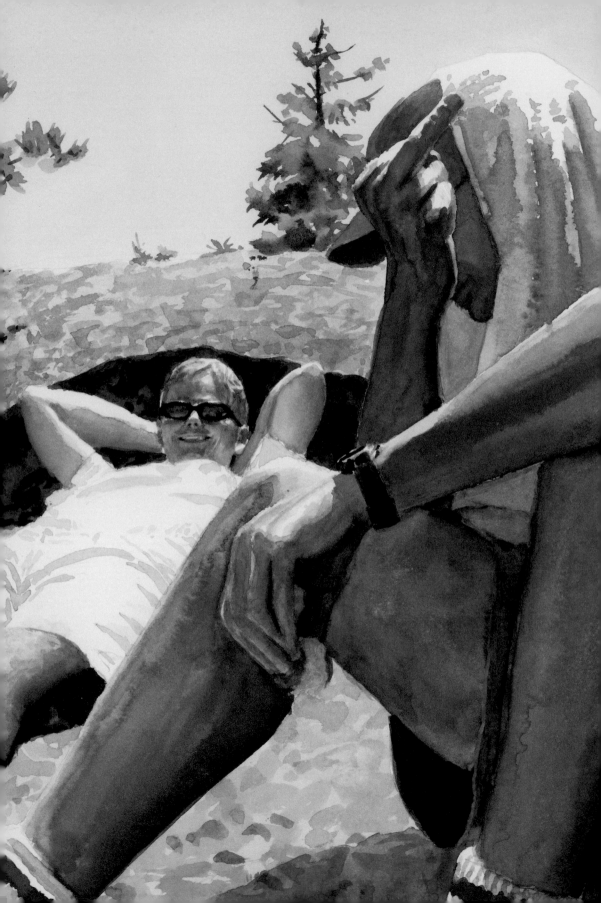

ARTIST **Tim Gardner**

AUTHOR Douglas Coupland

facing: **Tim Gardner** | Untitled (Hikers), 2009 (detail)

Douglas Coupland | City of Glass (excerpt)

GROUSE MOUNTAIN

In 1967 my father came home from a hunting trip with a deer strapped to the trunk of his Fairlane. Although we lived in the suburbs of West Van then, the appearance of a deer on a car's trunk seemed neither improper nor implausible. Within 450 metres (500 yards) of our house's front door was a chain-link fence that separates West Vancouver from what lies on the other side, which is, with the exception of the odd power line, logging road or train track, a raw wilderness. My parents still live near that house, and when visitors come from out of town, I take them up the Grouse Mountain Sky Ride and point it out while riding in the gondola. I also point out the wilderness to the north—just a quick scoot over the fence and visitors say, "Geez, Doug, I thought you were just being *metaphorical* about the wilderness . . ." They then stand and gawk at the Capilano Valley. The valley was logged long ago, so it's all second growth, but it can pass for wilderness nonetheless. *Boomp!*—the gondola berths at the top. The snow is thick; the nearby peaks loom, too steep to log or otherwise modify. This is where it dawns on everybody, from newcomers to season's ticket holders, that we live in a place that really has no equivalent anywhere else on Earth.

As teenagers, bored out of our minds during long summer holidays, we'd cable up Grouse Mountain and walk through the blueberry and salmonberry scrub to look for money that skiers had dropped in the rocks beneath the chairlifts. The most we ever found was a two-dollar bill, but we did see lots of rather fearless blue grouse—so the mountain is aptly named.

We bought season's passes for $99.00 back then, when the weather was colder and the winters were longer—and we pretty much lived on the slopes from November to March, on weekends and after school, thanks to night-time skiing. Not a week goes by now without a night-skiing dream—such a mythical flight-like sensation, to be swooping down the sodium-lit swaths of the runs, young and problemless and pure!

Grouse is open year-round, and not to be missed. The original 1960s James Bond Villain Alpine Retreat has been pasted over with a corny faux–Swiss chalet thingamabob. But the air is thin, the view is spectacular, and the presence of something holy is always just a breath and a glance away, off in the hinterlands.

—2000

Tim Gardner | Skier on Vancouver Island, 2009

Tim Gardner | Untitled (Hikers), 2009

ARTIST **Chris Gergley**
AUTHOR Michael Turner

facing: **Chris Gergley** | selected work from
Vancouver Apartments, 1997–98 (detail)

Michael Turner | The Pornographer's Poem (excerpt)

13.7

Saturdays I'd go downtown. Usually I'd go to A&A and buy a record.
Sometimes I'd buy an eight-track tape because my mom had a player in her
Falcon. Not that we had similar tastes in music. But there was one tape we
both seemed to agree on, and that was by Joan Armatrading. Mom really
liked the song "Love and Affection."

After A&A, I'd walk over to Robson Strasse, grab a schnitzel, then
mull over catching a matinee. The Cinémathèque had just opened and they
were showing all kinds of European films, which I liked because most of
them featured nudity. I kinda got addicted to those for a while. And I got
pretty good at telling which ones had nude scenes and which ones didn't.
I even came up with a system, this weird calculus based on what language
the film was in, what the movie poster looked like, when it was made, and
who was in it. But if you were to ask me which movies I saw or what they
were about—forget it. Most of the films made little or no sense to me at
the time. And I don't think it had to do with me forgetting to read the
subtitles every time a naked body appeared on screen. No, these movies
were weird. They didn't have conventional story lines like Hollywood
movies. And even if you thought they did—that is, if you began to recognize
something that resembled a story line—then, just as quick, the film would
veer off in another direction, almost like it was making fun of you for
even trying. In fact, a lot of these movies were similar to the films Penny
used to bring into the collective, films that intentionally worked away

from what she called "stock narrative." After a while, I got bored with the nude scenes. They never showed that much anyway.

My decision to catch a film was always based on my current supply of hash. If I was out, then I'd go over to Robin's. He'd just moved into an apartment on Davie Street, after his parents came to the conclusion that it wasn't the neighbourhood pets who were trampling their garden but Robin's clientele.

One time I went over to Robin's with some honey oil I got from Kai. I asked him if he wanted to smoke up and the guy gets all weepy, like he's about to cry. I asked him what's wrong and he tells me that nobody's ever done that to him before—come over with their own drugs and offered to smoke with him. I didn't know what to say, so I just did up a joint. After we got high, Robin told me how he now considered me a friend, and not just a customer. I thought that was a nice thing to say until he wrecked it by telling me something stupid like "friendship has its privileges," and that in future I could expect to get a discount. I told all this to Nettie, in a letter, and she wrote back that Robin had some confidence problems.

13.8

—You saw a lot of Robin Locke.

—Yeah.

—In fact, our records indicate that from April 1978 to June 1980 you visited Robin's apartment 137 times.

—Maybe.

—But you only purchased drugs from him on thirty-eight occasions.

—So?

—So there was something else attracting you besides the hashish.

—Maybe.

—1999

overleaf: **Chris Gergley** | selected works from
Vancouver Apartments, 1997–98 (details)

1295

NO CANVASSING
DELIVER AT REAR

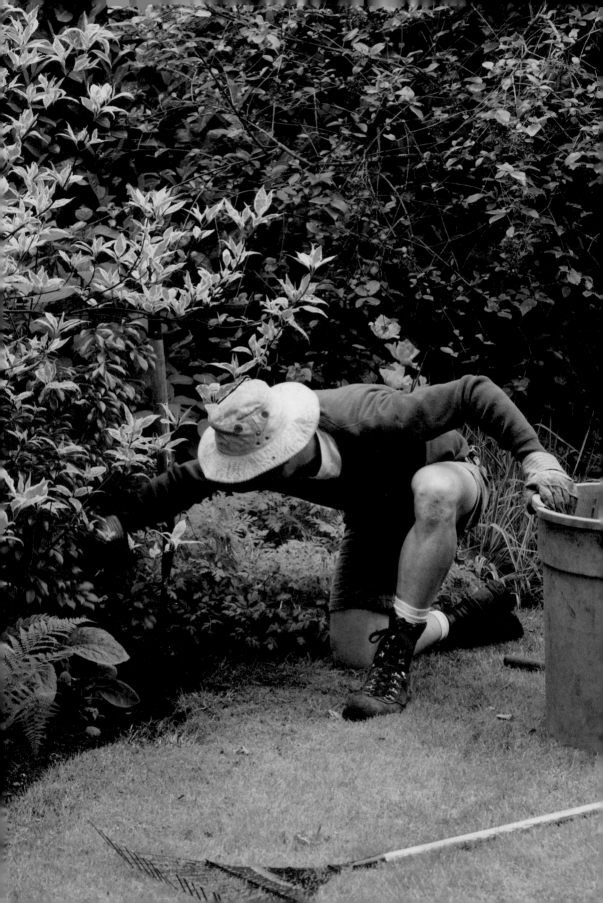

ARTIST **Scott McFarland**

AUTHOR David Watmough

facing: **Scott McFarland** | Pulling, Spring Maintenance,
Raymond Lachance, Vancouver, 2000 (detail)

David Watmough | Closeted (excerpt)

It was the kind of late February afternoon that can send Vancouverites mad with boasting. The temperature had been up in the high teens for nearly two weeks, with the bonus of an accompanying sun and cloud-enlivened skies. The rhythms of spring had thus settled upon us, with the early multi-colors of the bulbs, the hyacinths and crocuses, already pushed out of the way, mainly by the yellows from daffodils, forsythia, laburnum and broom. It was, in fact, the time of our west coast joy and complacency when we become buoyantly introverted in the face of grim weather bulletins still persisting from beyond the mountains to the east.

I parked the Peugeot outside the tennis courts where several young couples were playing—and paused to enjoy the exposed flesh before attending to my business in the building opposite. There was one pair in particular which held my attention. The girl was wearing a shirt and shorts. The boy was naked to the waist. Neither of them could have been a day over eighteen.

I didn't exactly sigh over the allure of youth—I wasn't feeling *that* old—but the gap of roughly twenty years between us was certainly sufficient to prompt a stab of nostalgia for that energy and freedom from wrinkle or blemish which adolescence can sometimes so beautifully demonstrate.

The two of them were intense in their performance and fairly equal in prowess. There was a lot of volleying and a few wasted shots. Not unnaturally, his service was the more powerful, and from time to time, during the few minutes I stood observing them, the ball from his far side of the court would elude her and end up by the plastic green meshing which separated the hardtop from the narrow earth bed on my side which was seasonally adorned with vermilion camellias with their background of dark green leaves.

When I finally turned away to attend to my concerns, it was with a welcome sense of satisfaction. The sun, the bright-colored camellias, the young exposed skin, all melded into a major constituent of the euphoria which enveloped me as I crossed the street into the sharp shadows.

—1982

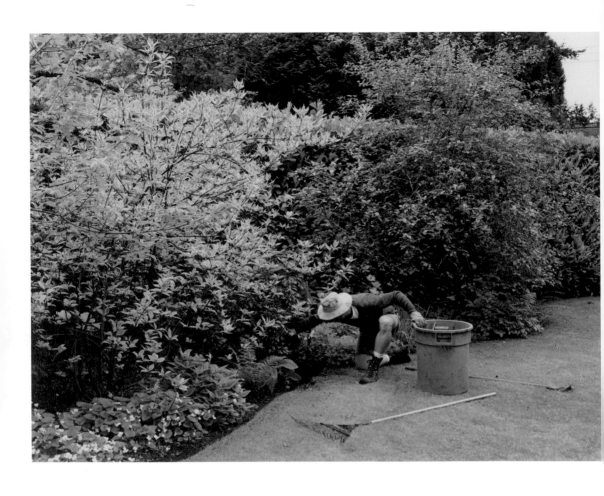

Scott McFarland | Pulling, Spring Maintenance,
Raymond Lachance, Vancouver, 2000

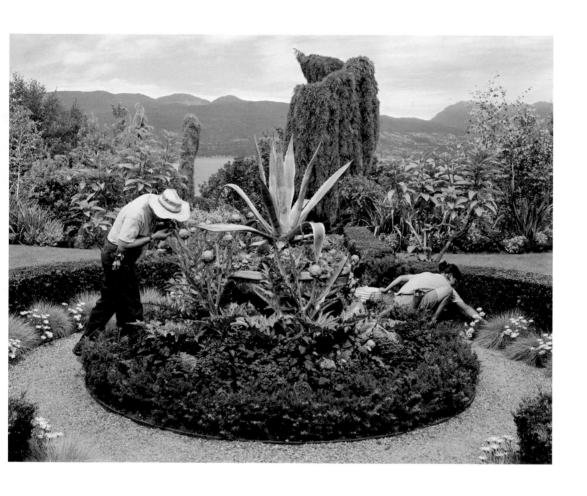

Scott McFarland | Inspecting, Allan O'Connor
Searches for Botrytis cinerea, 2003

ARTIST **Karin Bubaš**

AUTHOR Clint Burnham

facing: **Karin Bubaš** | Leon's Palace—
Kitchen (**Kitchen** 2), 2001 (detail)

Clint Burnham | Smoke Show (excerpt)

The radio was on late at night. How was that?

Jimmy at their place, Jimmy and Lucy's house of crack. East Van, trees on the streets, little houses for sale.

Jimmy was wondering.

Oh yeah well you know like, umm, yeah, well, you know like whatevah, umm, so like you know, so like what's up with them? I mean it's like it—like it's—ah they're pretty neat, I'm amazed at how much people, you know, go to the effort.

Well, this is the name for them. They were sitting in their living room, the entertainment centre.

What was that one I smelled the other night, reminded me of my grandparents' place?

Boxwood.

Yeah. Yeah. Boxwood. Man, when I get that smell, I don't know, it's like hedge city, I can just remember, I don't know. He sprawled on the chair. What's in—what's interesting is they're not solid. They're one of those things where they look solid but they're not.

Yeah, good, with ya so far.

No cuz you know cuz they're just trimmed, right? I mean, they don't grow as these big square or whatever things.

Brilliant. Stop the presses.

No just wait. So—

When, we were kids, when we'd go walking with my dad, he'd throw us in hedges. Yeah, he'd just suddenly push us into a hedge.

Did you like it?

Oh, we loved it. Are you kidding? A chance to tear clothing? Don't pass it up. Mandatory.

So what are hedges then? Why're they there?

Oh c'mon. Figure it out on your own time.

—2005

Karin Bubaš | Leon's Palace—Kitchen
(Kitchen 1, Kitchen 2, and Life Poem), 2001

683-001 CLIFFE
Somewhere in all this madness
There must be an end to my sadness
For all the love I try to give
Just soaksthrough like a Sieve

60-2638 Christopher 97
3035
ane- HNY #1 UPPER LEVELS
 N VAN
PARK
ROYAL MATURE forc CAP MALL
 QUAY

EDGEMONTVILL

235

List of Illustrations

This list includes all the artworks in this book, in order of appearance. Illustrations that do not have captions where they appear are fully described in the list below. A complete list of works in the exhibition *Visions of British Columbia: A Landscape Manual* is available at http://projects.vanartgallery.bc.ca/publications/visions_of_British_Columbia/visions_list_of_works.pdf. All measurements are given in centimetres (height by width by depth).

All works of art that appear as details are reproduced in full within the body of the publication or the following list of illustrations.

p. ii
William McFarlane Notman
Great Cedar Tree, Stanley Park, Vancouver, 1897
albumen print
18.4 × 23.1 cm
Collection of the Vancouver Art Gallery, Vancouver Art Gallery Acquisition Fund

p. iii
Emily Carr
Red Cedar, 1931
oil on canvas
111.0 × 68.5 cm
Collection of the Vancouver Art Gallery, Gift of Mrs. J.P. Fell

p. iv
Takao Tanabe
Cook Channel, Nootka Sound, 1996
etching on paper
49.1 × 57.0 cm
Collection of the Vancouver Art Gallery, Gift of the Artist

p. v
George Hunter
Tasu, Queen Charlottes—Wesfrob Base Metals Mines, 1971
silver gelatin print
25.4 × 20.5 cm
Collection of the Vancouver Art Gallery, Gift of the Artist, George Hunter RCA

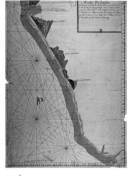

p. vi
Jose Canizares
Carta Reducida del Oceano Asiatico . . . , 1774
38.1 × 28.9 cm
Original in the National Archives, Washington, USA
Courtesy of Derek Hayes, White Rock

front cover, p. vii
Christos Dikeakos
Former site of Expo '86, a memory of sturgeon fishing—sḵwácháy's, "hole in bottom," 1992
chromogenic print, etched glass
35.3 × 87.1 cm
Collection of the Vancouver Art Gallery, Vancouver Art Gallery Acquisition Fund with the financial assistance of the Canada Council for the Arts Acquisitions Assistance Program

p. viii
Stuart Thompson
On the Georgia Viaduct, no date
silver gelatin print
35.8 × 48.3 cm
Collection of the Vancouver Art
Gallery, Purchased with funds
from the B.C. Cultural Fund

front cover, p. ix
E.J. Hughes
Untitled (Caterpillar moving logs),
1939
pencil, watercolour, ink on paper
30.5 × 37.9 cm
Collection of the Vancouver Art
Gallery, Vancouver Art Gallery
Acquisition Fund

p. x, 144, 149
Richard Hunt
*Mask Representing the
Ancestral Sun*, 1978
red cedar, paint
50.5 × 58.0 × 20.0 cm
Private Collection, Nanaimo

p. xi, 170–71
Ken Lum
Panda, 2007
lacquer paint, acrylic sheet,
aluminum
178.0 × 207.0 cm
Collection of the Vancouver Art
Gallery, Gift of the Artist

p. xii
Karin Bubaš
*Leon's Palace—Room 1 (Bedroom,
Bedside Table, Journal Entry)*, 2001
chromogenic print on wood
73.6 × 73.4, 73.9 × 73.9,
73.8 × 53.5 cm each
Collection of the Vancouver Art
Gallery, Gift of the Artist

p. xiii
**Paul Wong with
Kenneth Fletcher**
from *Murder Research*, 1977
chromogenic print,
silver gelatin print, videotape
dimensions variable
Collection of the Vancouver Art
Gallery, Vancouver Art Gallery
Acquisition Fund

p. xvi, 102
Ingrid Baxter and Iain Baxter
Bagged Landscape, 1966
vinyl
73.0 × 58.0 × 8.0 cm
Collection of the Vancouver Art
Gallery, Vancouver Centennial
Award Purchase Prize

p. xix
Stan Douglas
*Russian Orthodox Church at Stamps
Place (Strathcona series)*, 1998
chromogenic print
45.7 × 55.9 cm
Collection of the Vancouver
Art Gallery, Vancouver Art
Gallery Acquisition Fund with
financial support from the
Gelmont Foundation

p. xx, 27
Emily Carr
Strangled by Growth, 1931
oil on canvas
64.0 × 48.6 cm
Collection of the Vancouver Art
Gallery, Emily Carr Trust

pp. 4, 117
Jeff Wall
River Road, 1994
transparency in lightbox
90.5 × 119.0 cm
Collection of the Vancouver Art
Gallery, Gift of Michael Audain
and Yoshiko Karasawa

p. 9
Kevin Schmidt
Long Beach Led Zep, 2002
single-channel video projection
8 minutes, 42 seconds loop
Collection of Zoe Lasham
and Reid Shier
Courtesy Catriona Jeffries,
Vancouver

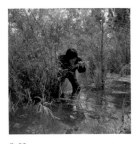

p. 10
Jin-me Yoon
Fugitive (Unbidden #3), 2004
transmounted chromogenic print
94.0 × 94.0 cm
Courtesy Catriona Jeffries,
Vancouver

p. 15
Michael Nicoll Yahgulanaas
Looking Out #11, 2006
watercolour, graphite,
ink on paper
24.4 × 30.6 cm
Collection of the Vancouver Art
Gallery, Gift of the Artist

pp. 16, 20–21
Charles Edenshaw
Plate, late 19th century
argillite
37.5 cm × 5.7 cm depth
Collection of the Museum of
Vancouver

p. 22
Emily Carr
*Scorned as Timber, Beloved
of the Sky*, 1935
oil on canvas
112.0 × 68.9 cm
Collection of the Vancouver Art
Gallery, Emily Carr Trust

p. 26
Emily Carr
Above the Trees, c. 1939
oil on paper
91.2 × 61.0 cm
Collection of the Vancouver Art
Gallery, Emily Carr Trust

pp. 28–29
Emily Carr
Above the Gravel Pit, 1937
oil on canvas
77.2 × 102.3 cm
Collection of the Vancouver Art
Gallery, Emily Carr Trust

p. 30
Willie Seaweed
Mask, c. 1940
red cedar, bark, cedar, feather,
cord, cloth, paint, dye
125.5 × 114.0 × 28.5 cm
Collection of the Royal British
Columbia Museum, #17377

p. 33
Willie Seaweed
Mask, c. 1926
cedar, bark, feather, cord, cloth,
cotton, leather, copper, paint, dye
105.0 × 93.0 × 25.0 cm
Collection of the Royal British
Columbia Museum, #15055

pp. 34, 41
Frederick Horsman Varley
Blue Ridge, Upper Lynn, 1931–32
oil on wood panel
31.0 × 38.0 cm
Collection of the Vancouver Art
Gallery, Vancouver Art Gallery
Acquisition Fund

pp. 38–39
Frederick Horsman Varley
Mountain Vista, B.C., c. 1929
oil on wood panel
30.0 × 37.0 cm
Collection of the Vancouver Art
Gallery, Vancouver Art Gallery
Acquisition Fund

p. 40
Frederick Horsman Varley
Bridge over Lynn Canyon, 1932–35
watercolour, gouache, chalk
on paper
21.8 × 26.3 cm
Collection of the Vancouver Art
Gallery, Vancouver Art Gallery
Acquisition Fund

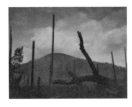

p. 42
John Vanderpant
In the Wake of the Forest Fire, 1926
silver gelatin print
27.0 × 34.8 cm
Collection of the Vancouver Art
Gallery, Vancouver Art Gallery
Acquisition Fund

p. 46
John Vanderpant
Untitled (Steel), 1934
silver gelatin print
24.9 × 19.8 cm
Collection of the Vancouver Art
Gallery, Vancouver Art Gallery
Acquisition Fund

p. 47
John Vanderpant
Temples on the Sea Shore, no date
silver gelatin print
34.7 × 27.4 cm
Collection of the Vancouver
Art Gallery, Gift of the Harry
Hood Estate

pp. 48, 52
Sybil Andrews
Logging Team, 1952
linocut on paper
34.7 × 41.3 cm
Collection of the Vancouver Art
Gallery, Vancouver Art Gallery
Acquisition Fund

p. 53
Sybil Andrews
Hauling, 1952
linocut on paper
30.2 × 35.9 cm
Collection of the Vancouver Art
Gallery, Vancouver Art Gallery
Acquisition Fund

pp. 54, 58, 59
Jack Shadbolt
Hornby Suite, 1971
charcoal on paper
101.0 × 65.7 cm each
Collection of the Vancouver Art
Gallery, Gift of J. Ron Longstaffe

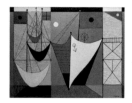

p. 60
B.C. Binning
Ships and Tower, 1948
oil on wood panel
81.1 × 102.4 cm
Collection of the Vancouver Art
Gallery, Gift of J. Ron Longstaffe

p. 63
B.C. Binning
Garden Potting Shed, c. 1945
ink on paper
61.1 × 45.6 cm
Collection of the Vancouver
Art Gallery, Gift of Mrs. Jessie
Binning

pp. 64–65
B.C. Binning
Convoy at Rendezvous, 1948
oil on canvas
40.7 × 76.2 cm
Collection of the Vancouver Art
Gallery, Bequest of C.S. Band

pp. 66, 71
E.J. Hughes
Farm near Courtenay, B.C., 1949
oil on canvas
77.0 × 97.0 cm
Collection of the Vancouver Art
Gallery, Allied Officers Women's
Auxiliary Picture Purchase Fund

p. 70
E.J. Hughes
Qualicum, 1958
oil on canvas
63.5 cm × 93.5 cm
Collection of the Vancouver Art
Gallery, Anonymous Gift

p. 72
Gordon Smith
Barkley Sound, 1987
acrylic on canvas
170.5 × 127.5 cm
Collection of the Vancouver Art
Gallery, Gift of Leon Tuey, Inc.

pp. 76–77
Gordon Smith
Untitled, 1996
acrylic on canvas
244.0 × 171.0
Collection of the Vancouver Art
Gallery, Vancouver Art Gallery
Acquisition Fund

pp. 78, 82–83
Dill Reid
*Phyllidula The Shape of Frogs
to Come*, 1984–85
red cedar, stain
42.5 × 87.0 × 119.0 cm
Collection of the Vancouver Art
Gallery, Vancouver Art Gallery
Acquisition Fund

pp. 81, 245
Bill Reid
Bear, 1981
bronze
7.1 × 7.8 × 6.4 cm
Collection of the Vancouver Art
Gallery, Gift of Takao Tanabe

pp. 84, 88–89
Roy Kiyooka
*Untitled (Opposite Blue Mule Studio,
Powell Street)*, 1978–80
silver gelatin print
38.5 × 187.0 cm
Collection of the Vancouver Art
Gallery, Vancouver Art Gallery
Acquisition Fund

p. 87
Roy Kiyooka
Back Alley, 1978
single-channel video transferred
from 8-mm film
19 minutes, 28 seconds
Courtesy Catriona Jeffries,
Vancouver

pp. 90, 95
Gathie Falk
Piece of Water: Libya, 1981
oil on canvas
197.5 × 167.0 cm
Collection of the Vancouver Art
Gallery, Gift of J. Ron Longstaffe

p. 94
Gathie Falk
Cement with Black Shadow, 1983
oil on canvas
198.0 × 122.0 cm
Collection of the Vancouver Art
Gallery, Gift of the Artist

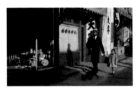

p. 96
Fred Herzog
Black Man Pender, 1958
ink jet print
71.2 × 97.0 cm
Collection of the Vancouver
Art Gallery, Purchased
with funds from the Jean
MacMillan Southam Major
Art Purchase Fund

p. 99
Fred Herzog
Fishseller, 1958
ink jet print
96.8 × 71.5 cm
Collection of the Vancouver
Art Gallery, Purchased
with funds from the Jean
MacMillan Southam Major
Art Purchase Fund

pp. 100–101
Fred Herzog
Westend from Burrard Bridge, 1957
ink jet print
71.6 × 96.8 cm
Collection of the Vancouver
Art Gallery, Purchased
with funds from the Jean
MacMillan Southam Major
Art Purchase Fund

p. 107, endpages
N.E. Thing Co.
(Ingrid Baxter and Iain Baxter)
You Are Now in the Middle of an N.E.
Thing Company Landscape, c. 1968
ink, silver gelatin print on paper
60.7 × 86.3 cm
Collection of the Vancouver Art
Gallery, Vancouver Art Gallery
Acquisition Fund

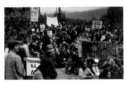

p. 108
Ian Wallace
Clayoquot Protest (August 9, 1993)
I, 1993–95
chromogenic print,
acrylic on canvas
152.0 × 122.0 cm
Collection of the Vancouver Art
Gallery, Gift of the Artist

p. 112
Ian Wallace
Clayoquot Protest (August 9, 1993)
III, 1993–95
chromogenic print,
acrylic on canvas
198.0 × 152.0 cm
Collection of the Vancouver Art
Gallery, Gift of the Artist

p. 113
Ian Wallace
Clayoquot Protest (August 9, 1993)
II, 1993–95
chromogenic print,
acrylic on canvas
122.5 × 198.0 cm
Collection of the Vancouver Art
Gallery, Gift of the Artist

p. 114
Jeff Wall
Landscape Manual, 1970
ink on paper
26.5 × 21.0 cm
Collection of the Vancouver Art
Gallery, Gift of Robert Kleyn

pp. 118–19
Jeff Wall
The Pine on the Corner, 1990
transparency in lightbox
135.3 × 165.0 × 25.8 cm
Collection of the Vancouver Art
Gallery, Vancouver Art Gallery
Acquisition Fund

pp. 120, 124–25
Robert Davidson
Killer Whale Transforming into a
Thunderbird, 2009
wood, paint
304.8 × 91.4 × 91.4 cm
Commissioned with funds
from Arts Partners in Creative
Development, the Jean MacMillan
Southam Major Art Purchase
Fund and Gary Bell

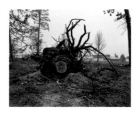

p. 183, back cover
Lawrence Paul Yuxweluptun
The Impending Nisga'a' Deal. Last
Stand. Chump Change, 1996
acrylic on canvas
201.0 × 245.1 × 5.1 cm
Collection of the Vancouver Art
Gallery, Vancouver Art Gallery
Acquisition Fund

pp. 184, 188–89
Stan Douglas
Every Building on
100 West Hastings Street, 2001
chromogenic print
119.5 × 486.5 cm
Collection of the Vancouver Art
Gallery, Vancouver Art Gallery
Acquisition Fund with the
financial assistance of the Louis
Comtois Trust

pp. 190, 193, 194–95
Jin-me Yoon
A Group of Sixty-seven, 1996
chromogenic print
dimensions variable
Collection of the Vancouver Art
Gallery, Vancouver Art Gallery
Acquisition Fund

pp. 196, 200–201
Brian Jungen
Cetology, 2002
plastic chairs
161.5 × 1260.4 × 168.7 cm
Collection of the Vancouver
Art Gallery, Purchased with
the financial support of the
Canada Council for the Arts
Acquisition Assistance Program
and the Vancouver Art Gallery
Acquisition Fund

p. 199
Brian Jungen
Prototype for New
Understanding #3, 1999
Nike Air Jordans
28.0 × 12.8 × 20.5 cm
Collection of the Vancouver Art
Gallery, Purchased with the finan-
cial support of the Canada Council
for the Arts Acquisition Assistance
Program and the Vancouver Art
Gallery Acquisition Fund

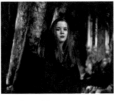

pp. 202, 205
Althea Thauberger
not afraid to die, 2001
single-channel video projection
5 minutes, 35 seconds (repeats)
Collection of the Vancouver Art
Gallery, Purchased with the finan-
cial support of the Canada Council
for the Arts Acquisition Assistance
Program and the Vancouver Art
Gallery Acquisition Fund

pp. 206, 210, 211
Kevin Schmidt
Fog Study, 2004
light jet photograph
61.0 × 61.0 cm each
Courtesy Catriona Jeffries,
Vancouver

pp. 212, 217
Tim Gardner
Untitled (Hikers), 2009
watercolour on paper
40.6 × 50.8 cm
Courtesy of 303 Gallery,
New York

p. 216
Tim Gardner
Skier on Vancouver Island, 2009
watercolour on paper
43.2 × 55.9 cm
Courtesy of 303 Gallery,
New York

pp. 218, 222, 223
Chris Gergley
Selected works from *Vancouver*
Apartments, 1997–98
chromogenic prints
Courtesy of Monte Clark Gallery
and Old Mill Editions

pp. 224, 228
Scott McFarland
Pulling, Spring Maintenance,
Raymond Lachance, Vancouver, 2000
chromogenic print
76.0 × 95.5 cm
Collection of the Vancouver Art
Gallery, Gift of Michael Audain
and Yoshiko Karasawa

p. 229
Scott McFarland
Inspecting, Allan O'Connor
Searches for Botrytis cinerea, 2003
chromogenic print
102.0 × 122.0 cm
Courtesy of the Artist and
Union Gallery, London

pp. 230, 234–35
Karin Bubaš
Leon's Palace - Kitchen (Kitchen 1,
Kitchen 2, and Life Poem), 2001
chromogenic print on wood
73.7 × 73.5 cm; 73.6 × 73.6 cm;
73.7 × 53.3 cm
Collection of the Vancouver Art
Gallery, Vancouver Art Gallery
Acquisition Fund with the finan-
cial assistance of Rose Emery

p. 261
Fred Herzog
Howe and Nelson, 1960
ink jet print
71.3 × 97.0 cm
Collection of the Vancouver Art
Gallery, Gift of the Artist

p. 262
Jeff Wall
Logs, 2002
silver gelatin print
180.0 × 221.3 × 6.4 cm
Collection of Iqbal and
Yasmin Kassam

endpages
Mattie Gunterman
Coming through Roger's Pass, 1896,
1896
silver gelatin print
17.1 × 25.2 cm
Collection of the Vancouver Art
Gallery, Purchased with funds
from the B.C. Cultural Fund

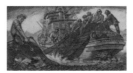

endpages
Paul Goranson
B.C. Purse Seiners, 1940
drypoint on paper
20.2 × 37.6 cm
Collection of the Vancouver Art
Gallery, Vancouver Art Gallery
Acquisition Fund

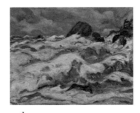

endpages
Jock Macdonald
Graveyard of the Pacific, 1935
oil on board
31.0 × 38.5 cm
Collection of the Vancouver Art
Gallery, Vancouver Art Gallery
Acquisition Fund

back cover
Emily Carr
Old Time Coast Village, 1929–30
oil on canvas
91.3 × 128.7 cm
Collection of the Vancouver Art
Gallery, Emily Carr Trust

243

Photo Credits

facing: **Bill Reid** | Bear, 1981 (detail)

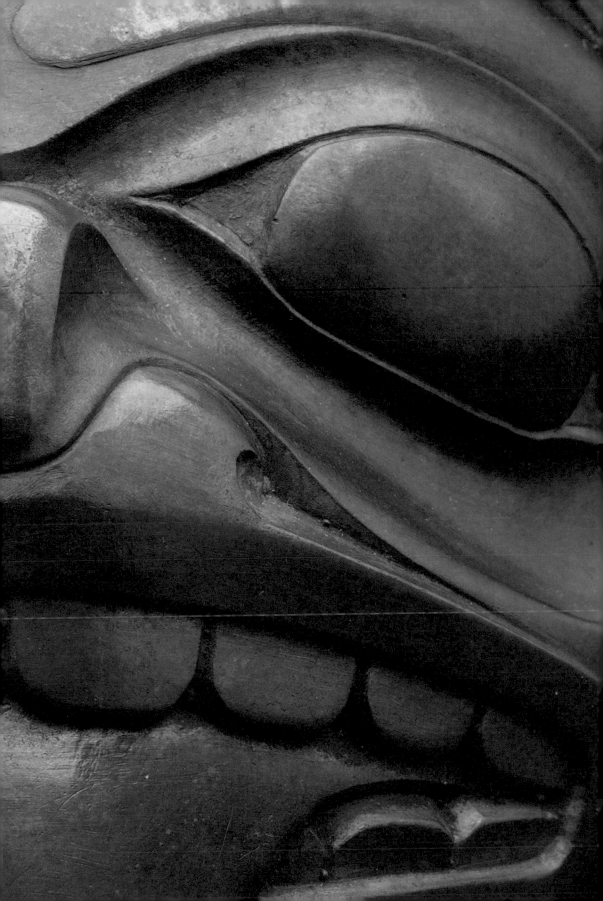

Text Sources

Every reasonable effort has been made to acknowledge the ownership of copyright textual material included in this volume. Any errors that may have occurred are inadvertent and will be corrected in subsequent editions, provided notification is sent to the publisher.

Page 17: Excerpt from *Argillite: Art of the Haida* by Leslie Drew and Douglas Wilson, Hancock House, Surrey, B.C., 1980. Permission of Hancock House Publishers.

Page 23: Excerpt from "Eating Dirt" by Charlotte Gill, first published in *The Vancouver Review*, October 2007. Permission of the author.

Page 31: "The Birds of Heaven" transcribed by Franz Boas in *The Religion of the Kwakiutl Indians*, Columbia University Press, New York, 1930.

Page 35: Excerpt from *The Well of Loneliness* by Radclyffe Hall, Jonathan Cape, London, 1928.

Page 43: Excerpt from "The Spark of Death" by Hubert Evans, first published in *The Silent Call*, Dodd, Mead & Co., New York, 1930. Permission of the Estate of Hubert Evans.

Page 49: Excerpt from *The Golden Spruce: A True Story of Myth, Madness, and Greed* by John Vaillant, Knopf Canada, 2005. Canada permission of Knopf Canada. United States permission of W.W. Norton & Company Inc. and Liveright Publishing Corporation. UK permission of The Random House Group Ltd.

Page 55: Excerpt from *Hundreds and Thousands: The Journals of Emily Carr* by Emily Carr, Clarke, Irwin & Co., Toronto, 1966; new edition Douglas & McIntyre, Vancouver, 2006. Permission of D&M Publishers.

Page 61: "Happiness" by Malcolm Lowry, first published posthumously in *Selected Poems*, City Lights, San Francisco, 1962.

Page 67: Excerpt from "The Man with Clam Eyes" by Audrey Thomas, from *Goodbye Harold, Good Luck*, Penguin, 1986. Permission of the author.

Page 73: Excerpt from "The Forest Path to the Spring" by Malcolm Lowry, first published posthumously in *Hear Us O Lord from Heaven Thy Dwelling Place*, Lippincott, Philadelphia, 1961.

Page 79: "This Box of Treasures" by Guujaaw, reproduced in *Raven Travelling: Two Centuries of Haida Art*, Douglas & McIntyre, Vancouver, 2006. Permission of D&M Publishers.

Page 85: Poem by Roy Kiyooka from *Pear Tree Pomes*, first published in 1987 by Coach House Press, Toronto. Permission of Talonbooks.

Page 91: Excerpt from *Hetty Dorval* by Ethel Wilson, Macmillan Books, Toronto, 1947; new edition New Canadian Library, Toronto, 2008. Permission of the University of British Columbia.

Page 97: Excerpt from *The Jade Peony* by Wayson Choy, Douglas & McIntyre, Vancouver, 1995. Permission of D&M Publishers.

Page 103: "killer whale" from *Nobody Owns Th Earth* by bill bissett, Anansi Press, Toronto, 1971. Permission of Talonbooks.

Page 109: Excerpt from "The Clayoquot Papers" by Maurice Gibbons, first published in *Clayoquot and Dissent*, Ronsdale Press, Vancouver, 1997. Permission of Ronsdale Press.

Page 115: Excerpt from "About Making Landscapes" by Jeff Wall, from *Jeff Wall: Selected Essays and Interviews*, Museum of Modern Art, New York, 2007. Permission of the author.

Page 121: Excerpt from "Out of the Silence" by Bill Reid, first published in *Solitary Raven: Selected Writings of Bill Reid*, Douglas & McIntyre, Vancouver, 1971. Permission of D&M Publishers.

Page 127: Excerpt from *A Ghost in the Water* by Terry Glavin, Transmontanus Books, a series published by New Star Books, Vancouver, 1994. Permission of New Star Books.

Page 133: Excerpt from *The Curve of Time* by M. Wylie Blanchet, W. Blackwood, Edinburgh, 1961; new edition Whitecap Books, Vancouver, 1990. Permission of Whitecap Books.

Page 139: Excerpt from *Stanley Park* by Timothy Taylor, Knopf Canada, 2001. Permission of Knopf Canada. Permission of Random House of Canada and The Cooke Agency.

Page 145: Excerpt from *The Jesup North Pacific Expedition, Memoir of the American Museum of Natural History, volume 10, part 1, Kwakiutl Texts*, edited by Franz Boas, E.J. Brill, Leiden, 1905.

Page 151: "generation, generations at the mouth" by Daphne Marlatt, from new edition of *Steveston: poems*, Ronsdale Press, Vancouver, 2001. Permission of Ronsdale Press.

Page 157: Poem by 'Laana awga Chief Sgiidagiids, never before published. Permission of the author's family. Haawa' to Michael Nicoll Yahgulanaas and Jenny Cross for arranging this.

Page 163: "BC Collateral" by Joseph Ferone, from *A Verse Map of Vancouver*, Anvil Press, Vancouver, 2009. Permission of Anvil Press.

Page 167: Excerpt from "Simple Recipes" by Madeleine Thien, from *Simple Recipes*, McClelland & Stewart, Toronto, 2001. Permission of McClelland & Stewart.

Page 173: Excerpt from *Chasing Clayoquot: A Wilderness Almanac* by David Pitt-Brooke, Raincoast Books, Vancouver, 2004. Permission of D&M Publishers.

Page 179: Excerpt from *Stolen Continents: The "New World" through Indian Eyes* by Ronald Wright, Viking Canada, 1992. Permission of Houghton Mifflin Harcourt.

Page 185: "How Many White People Noticed (and recounted the scene over dinner)" by Gregory Scofield, from *Native Canadiana: Songs from the Urban Rez*, Polestar, Victoria, B.C., 1996. Permission of the author.

Page 191: "for kwong lee taitai, who landed in victoria the year of the monkey, 1860" by Rita Wong, from *monkeypuzzle*, Press Gang, Vancouver, 1998. Permission of the author.

Page 197: Excerpt from "Whales" by Douglas Coupland, from *City of Glass: Douglas Coupland's Vancouver*, Douglas & McIntyre, Vancouver, 2000 (new edition 2009). Permission of D&M Publishers.

Page 203: "How to Hunt" by Fred Wah, from *Owners Manual*, Island Writing Series, Lantzville, B.C., 1981. Permission of the author.

Page 207: Excerpt from *Hundreds and Thousands. The Journals of Emily Carr* by Emily Carr, Clarke, Irwin & Co., Toronto, 1966; new edition Douglas & McIntyre, Vancouver, 2006. Permission of D&M Publishers.

Page 213: "Grouse Mountain" by Douglas Coupland, from *City of Glass: Douglas Coupland's Vancouver*, Douglas & McIntyre, Vancouver, 2000 (new edition 2009). Permission of D&M Publishers.

Page 219: Excerpt from *The Pornographer's Poem* by Michael Turner, Vintage Canada, 1999. Permission of Doubleday Canada.

Page 225: Excerpt from "Closeted" by David Watmough, first published in *Waves* magazine, vol. 10, no. 4, Spring 1982. Permission of the author.

Page 231: Excerpt from *Smoke Show* by Clint Burnham, Arsenal Pulp Press, Vancouver, 2005. Permission of Arsenal Pulp Press.

Artist Biographies

Sybil Andrews (b. 1898, Bury St. Edmunds, U.K.; d. 1992, Campbell River, Canada) is known for her dynamic, modernist prints. She made her first linocut in 1929 and over the next sixty years created eighty more. After the Second World War, in 1947, she immigrated to Canada and settled in Campbell River, a logging town on Vancouver Island. Her work is concerned with the depiction of movement and purity of form as expressed by activities of humans, machines and forces of nature.

Roy Arden (b. 1957, Vancouver, Canada) has been photographing Vancouver's urban environment since the early 1990s. His photographs of Vancouver's streets, houses and industrial lots explore his interest in local history and modernity. Arden attempts to capture "the landscape of the economy"—the social and economic history of Vancouver and its suburbs. Since the early 1980s Arden has exhibited extensively nationally and internationally, and his work is represented in numerous public collections.

B.C. Binning (b. 1909, Medicine Hat, Canada; d. 1976, Vancouver, Canada) was an influential artist and architectural innovator who studied at the Vancouver School of Decorative and Applied Arts, where he later taught. He was noted for his accomplished drawings and vibrant paintings, both of which often reflected his fascination with West Coast marine activity. In 1949, Binning joined the faculty of the new School of Architecture at the University of British Columbia, becoming the head of the fine arts department, where he taught until his death. Binning's work has been included in more than forty-five exhibitions at the Vancouver Art Gallery, including six solo exhibitions.

Karin Bubaš (b. 1976, Vancouver, Canada) has focused her photographic practice on arrangements of ordinary and banal objects that she has studied to reveal the intimate details of human presence and character acting as psychological profiles of the absent owners of the objects. Her recent series *Studies in Landscape and Wardrobe* combines figure

studies with an exploration of the landscape of British Columbia. Her work was the subject of a 2008 solo exhibition at the Canadian Cultural Centre in Paris. She lives and works in Vancouver.

Emily Carr (b. 1871, Victoria, Canada; d. 1945, Victoria, Canada) is considered the pre-eminent artist in the history of British Columbia painting and stands today as a major figure in the development of the modern movement in Canadian art. The B.C. landscape and Native themes dominate her work. Group and solo exhibitions of Carr's work have been organized extensively in Canada, and her work is held in all major public collections in Canada.

Robert Davidson (b. 1946, Hydaburg, U.S.) is strongly influenced in his work by his Haida ancestry, including the work of his great-grandfather Charles Edenshaw. Davidson moved with his family to Masset on Haida Gwaii in 1947 and lived there until 1965, when he moved to Vancouver to complete his secondary school education. Davidson's diverse artistic production includes sculpture in wood and bronze, jewellery, drawings, prints, and paintings on drums, paper and canvas. His work reveals great sophistication in the Haida artistic vocabulary while consistently demonstrating a willingness to change and adapt its forms and iconography to address contemporary life.

Christos Dikeakos (b. 1946, Thessaloniki, Greece) has lived in Vancouver since moving to Canada as a child. He has played an important role in the production and development of photo-based art in the city. Much of his work focuses on Vancouver as an urban centre while simultaneously acknowledging the diverse histories of the city and the colonization that has occurred there. His work challenges conventional representations of place and history and acknowledges the plurality of land use in relation to larger economic and ideological shifts over time.

Stan Douglas (b. 1960, Vancouver, Canada) explores the representation of social histories in both filmed and photographic images. His use of non-linear narratives questions the claim to neutrality made by the documentary format and disrupts narratives that portray society as a unified whole with one history and one system of

values. His work has been shown internationally in significant exhibitions, including Documenta X, Kassel (1997), Documenta XI, Kassel (2002), and the 51st Venice Biennale (2007), and is in important public collections internationally. He lives and works in Vancouver.

Charles Edenshaw (b. c. 1839, Skidegate, Canada; d. 1920, Masset, Canada) was an artist of Haida ancestry whose works include plates, bentwood boxes, rattles, masks, totem poles and staffs in a variety of media, including wood, argillite, gold and silver. His inspired handling of formline design led to a huge demand for his work. Edenshaw was a consultant to many anthropologists, and during his lifetime he was celebrated as one of his people's greatest carvers. His work has been highly influential on subsequent generations of artists.

Gathie Falk (b. 1928, Alexander, Canada) has a history as a performance artist, painter and sculptor that has spanned more than forty years. Her groundbreaking installations, ceramic sculptures and performance art of the 1960s and 1970s and her acclaimed paintings and sculptures of the past thirty years reveal the extraordinary in the ordinary, and the poignancy of familiar objects and sights. In recognition of her achievements she was awarded the Gershon Iskowitz Prize in 1990, was appointed to the Order of Canada in 1997 and received a Governor General's Award in 2003.

Tim Gardner (b. 1973, Iowa City, U.S.) works primarily in watercolour and oil pastel to create intimate paintings based on snapshots, often of family and friends enjoying leisure activities from sports to partying. Gardner now lives and works on Vancouver Island, and the Canadian landscape figures prominently in his works, often as a backdrop reminding the viewer of the unpredictability of the wilderness. He has exhibited his work internationally, including at the National Gallery, London; 303 Gallery, New York; and the Contemporary Art Gallery, Vancouver.

Chris Gergley (b. 1973, Regina, Canada) is a Vancouver-based photographer who works with both found and self-produced images to produce a complex narrative about his relationship to the medium and to question the different meanings images are given depending on their context. His work often examines quotidian aspects of North American cities. His major work *Vancouver Apartments*, 2005, is a typological series of eighty-eight photographs of middle-class apartment building lobbies, evidencing the rapid decay of these modernist buildings.

Rodney Graham (b. 1949, Abbotsford, Canada) has a rigorously intellectual practice that includes photography, film, video, music, sculpture, painting and books and often investigates our modes of perception and examines social and philosophical systems of thought. His work relates to the important tradition of photo-based conceptual art in Vancouver. Graham has an outstanding international solo and group exhibition history from the mid-1970s, including acting as Canada's representative to the Venice Biennale in 1996. His work is collected by public institutions worldwide.

Fred Herzog (b. 1930, Stuttgart, Germany) began taking colour photographs of Vancouver in 1953 and estimates that he has taken over 90,000 colour slides of the city of Vancouver alone, along with some 28,000 black and white images. Herzog's decision to work primarily in colour from the early days of his practice, during a period when colour photography in a documentary style was not considered an art form, makes him a pioneer in this realm. Herzog lives and works in Vancouver.

E.J. Hughes (b. 1913, North Vancouver, Canada; d. 2007, Duncan, Canada) focused on the landscape of British Columbia in his work, which is known for its remarkable clarity and a sense of wonder and love of the natural world that he depicted. His style is marked by flattened planes, skewed perspectives and simplified shapes, which give his works a "primitive" quality. A retrospective exhibition of Hughes's work was organized by the Vancouver Art Gallery in 2003 and travelled to the McMichael Canadian Art Collection, Kleinburg, and the Art Gallery of Greater Victoria.

Richard Hunt (b. 1951, Alert Bay, Canada) comes from a family of artists, including his grandfather Mungo Martin. His artistic style can be identified with the Kwakwaka'wakw tradition. In 1974 Hunt became chief carver in the Thunderbird Park Carving Program in Victoria, a position he held for twelve years. His diverse body of work includes screen prints, paintings on drums, boxes and jewellery; however, he is best known for his carving, often in traditional cedar. Among his public works, a carving by Hunt was selected for a major installation at the Vancouver International Airport. He has also produced ceremonial works for the Museum of Natural History in New York.

Brian Jungen (b. 1970, Fort St. John, Canada) is an artist of Swiss and Dunne-za descent who has emerged internationally as one of Canada's most acclaimed artists. Interested in the physicality of objects and their symbolic mutability, he transforms common, prefabricated consumer products into evocative sculptures and installations. His practice stages a rich dialogue between his First Nations ancestry, Western art history, the global economy and the art object. His work has been exhibited internationally, and in 2002 Jungen won the inaugural Sobey Art Award.

Roy Kiyooka (b. 1926, Moose Jaw, Canada; d. 1994, Vancouver, Canada) was an artist of Japanese heritage who worked in painting, sculpture, photography and film. He was also a poet. Kiyooka grew up in Calgary and moved to Vancouver in 1959, where he taught at the University of British Columbia. His work often included his daily community, especially featuring Vancouver's Downtown Eastside, and explored spectacles in quotidian life. He was appointed an officer of the Order of Canada in 1978.

Ken Lum (b. 1956, Vancouver, Canada) is a Vancouver artist of Chinese heritage who works in a variety of media, including sculpture, photography and installation. His practice investigates the ongoing negotiation of identity within processes of acculturation and the dialectics of private and public constructions of identity, space and politics. His work also explores the relationship between the culture of modernism (both mass and high culture) and our lived experiences. In addition to his international exhibition history and public art commissions, he co-founded *Yishu Journal of Contemporary Chinese Art* in 2000 and co-curated the seventh Sharjah Biennial, in the United Arab Emirates.

Liz Magor (b. 1948, Winnipeg, Canada) is a Vancouver-based artist whose practice has explored ideas around time, identity and a widely shared desire for seclusion and escapism. In her sculpture and installation works, Magor often casts objects, and in creating replicas of ordinary objects that look authentic, she communicates a disjuncture between appearance and reality. She has exhibited her work widely from the late 1970s, including at Documenta 8, Kassel (1987), and she was the 2009 recipient of the Audain Prize for Lifetime Achievement.

Scott McFarland (b. 1975, Hamilton, Canada) photographs a variety of landscapes in which relationships between civilization, culture and nature are investigated; these include his series on local gardens, a friend's cabin and boathouse, Huntington Gardens in Pasadena, Hampstead Heath in London and the Berlin Zoo. McFarland has an impressive exhibition history that includes group shows at the Museum of Modern Art, New York; Regen Projects, Los Angeles; and the Victoria and Albert Museum, London. His work is in numerous national and international collections.

N.E. Thing Co. was a conceptual enterprise based in Vancouver; it was founded by Iain Baxter (b. 1946, Middlesbrough, U.K.) in 1966, officially incorporated in 1969 and run with Ingrid Baxter (b. 1938, Spokane, U.S.) until 1978. N.E. Thing Co. produced ACT and ART (Aesthetically Claimed Things and Aesthetically Rejected Things), photography and film, and it consulted on projects to diversify its interventions into the environment, business and developing technologies. N.E. Thing Co. had a multidisciplinary approach that encouraged sensory experiences in addition to the strictly visual.

Susan Point (b. 1952, Alert Bay, Canada) is a Coast Salish artist who has lived in Vancouver since shortly after her birth. Using a wide range of techniques, including wood carving, printmaking, foil embossing, paper casting, linocuts and lithography, she has reinterpreted Coast Salish forms and used non-traditional colours in her work. Her willingness to explore new media and work on a large scale has won her numerous public art commissions, including at the Vancouver International Airport.

Bill Reid (b. 1920, Victoria, Canada; d. 1998, Vancouver, Canada) was an artist whose father was of German, Scottish and American descent and whose mother was Haida. Reid transformed Haida forms and myths into compelling and modern images in a range of media, including gold, platinum, silver, argillite, bronze, cedar and ink on paper, and he was pivotal to the rebirth of First Nations art on the Northwest Coast. His sculptures *The Black Canoe* and *The Jade Canoe* are at the Canadian Embassy in Washington, D.C., and the Vancouver International Airport respectively.

Kevin Schmidt (b. 1972, Ottawa, Canada) is a Vancouver-based artist whose work investigates the sublime and spectacular in nature, often taking cues from the pictorial tradition of landscape painting. He is also interested in the dichotomy between the real and the artificial, particularly with respect to the experience of the natural world. He has shown his work in group exhibitions internationally and is a recipient of a VIVA Award (2008).

Willie Seaweed (b. c. 1873, Nugent Sound, Canada; d. 1967, Blunden Harbour, Canada) was a Kwakwaka'wakw artist, singer and dancer. He was a renowned and prolific carver who produced almost every kind of ceremonial object used in Southern Kwakiutl society, from totem poles and painted house fronts to masks and whistles. Seaweed's work helped the progression of southern Kwakwaka'wakw art from the dominant "restrained" style of the nineteenth century to a more expressive and dramatic style.

Jack Shadbolt (b. 1909, Shoeburyness, U.K.; d. 1998, Burnaby, Canada) was a prolific painter of the landscape of British Columbia. After Shadbolt met the artist Emily Carr in 1930, he began drawing First Nations artifacts and made visits to provincial museums through the decade, incorporating his personal experiences of nature and Northwest Coast First Nations art into his practice. His work has been featured in over sixty solo exhibitions, including several exhibitions at the Vancouver Art Gallery beginning in 1936.

Gordon Smith (b. 1919, Hove, England) paints works that bridge the gap between pure abstraction and representation. Smith settled in Vancouver in 1940. By the late 1950s he had developed a form of lyrical abstraction that drew upon the natural environment of the West Coast while referencing broader international developments in art. By 1960, he had emerged as one of the leading modernist artists in British Columbia. Smith's work is held in every major institution in Canada, and he has been honoured with numerous awards, including the Governor General's Award in Visual and Media Arts in 2009. Smith was appointed to the Order of Canada in 1996.

Althea Thauberger (b. 1970, Saskatoon, Canada) completed her master of fine arts degree at the University of Victoria in 2002 and lives in Vancouver. Her films frequently focus on adolescence and notions of self-expression and individualism in contemporary culture. Thauberger often sets her central characters in Arcadian locations, addressing the romantic vision of the West Coast as a place of spiritual enlightenment through one's connection to the natural world. Recent solo exhibitions include White Columns, New York, and BAK, basis voor actuele kunst, in Utrecht, Netherlands, in 2007.

John Vanderpant (b. 1884, Alkmaar, Netherlands; d. 1939, Vancouver, Canada) is known for his modernist photographs that emphasize light and form. He came to Canada in 1911 and eventually settled in 1919 in Vancouver, where he opened a commercial portrait studio. His gallery on Robson Street, which he ran in collaboration with Harold Mortimer-Lamb, was a centre for music, intellectual debate and art. Vanderpant exhibited his work in international salons, quickly achieving acclaim and winning awards around the world; his solo exhibitions toured the United States, Great Britain and Europe.

Frederick Horsman Varley (b. 1881, Sheffield, U.K.; d. 1969, Toronto, Canada) was a founding member of the Group of Seven in 1920; they exhibited extensively together until 1932. He came to Canada in 1912 and moved to Vancouver in 1926 to head the department of painting and drawing at the Vancouver School of Decorative and Applied Arts, where he had a significant influence on early modernist painting in British Columbia. The vast and unfamiliar landscape of the province served as inspiration for Varley and opened up his work to new types of expression.

Jeff Wall (b. 1946, Vancouver, Canada) is a Vancouver-based artist who has played a key role in establishing photography as a contemporary art form. He is internationally renowned for his photo-transparencies mounted in lightboxes. He has also produced critical texts that have helped define the pivotal role of photography in the production of contemporary art. Wall has an outstanding exhibition history that reflects the respect for his practice and the fundamental significance of his work. His photographs are held in important public and private collections around the world.

Ian Wallace (b. 1943, Shoreham, U.K.) is a Vancouver-based artist known for work that combines photographic imagery with abstract painting on canvas, focusing on themes such as social responsibility, urban individuality and the position of the artist in society. He was an influential instructor at the University of British Columbia from 1967 to 1970 and at Emily Carr Institute of Art + Design from 1972 until his retirement in 1998. He has been exhibiting his work internationally since 1965, and examples of his practice can be found in numerous important public collections.

Paul Wong (b. 1955, Prince Rupert, Canada) has been active in Vancouver as an artist working with video, performance, installation and photography since the mid-1970s to explore sexual and cultural identity, violence and racism. In 1974 he co-founded Video In, a centre for independent video and experimental media art. His work has been exhibited widely and he has participated in biennials from Venice to Beijing. He was the recipient of the Governor General's Award in Visual and Media Arts in 2005.

Michael Nicoll Yahgulanaas (b. 1954, Prince Rupert, Canada) is a Haida artist and great-grandson of Charles Edenshaw. He has developed a new genre of drawings he refers to as Haida manga, which is a unique fusion of Haida narratives and Asian comic book styles. He also actively produces paintings, sculptures, bookworks and installation art. His work has been widely shown in Canada and Asia.

Jin-me Yoon (b. 1960, Seoul, Korea) is known for her photography and film, which often use the body to explore questions of cultural identity, history, memory and place. She immigrated to Vancouver in 1968, the year after immigration restrictions were lifted for certain Asian nationals. Her early work questions how we understand belonging in Canada as well as the construction of national identity in art, often using her own body to act as a symbol of hybridity. Her recent work explores culturally constructed urban and natural spaces, inviting viewers to reconsider the narratives that shape those spaces and the role of the body in providing a means to displace and disrupt those narratives.

Lawrence Paul Yuxweluptun (b. 1957, Kamloops, Canada) is a Coast Salish artist who deploys Northwest Coast First Nations design elements and Western landscape traditions in his vividly coloured paintings to confront issues such as aboriginal rights, treaty processes and the destruction of nature. Yuxweluptun has exhibited widely across Canada since 1984, and his work is held in collections nationally and internationally. He lives and works in North Vancouver.

EMMY LEE

bill bissett (b. 1939, Halifax, Canada) is one of Canada's most original and widely appreciated poets. Over five decades he has published more than sixty books, easily identified by his distinctive artwork and unique phonetic (or "funetik") spelling. He is renowned for his "concrete sound" performances, which include chanting and dancing. He has also exhibited his paintings widely, made audio recordings, and sung and written lyrics for an Ontario band, the Luddites. bissett's work mixes politics and mysticism with humour and an almost childlike sense of wonder.

M. Wylie Blanchet (b. 1891, Lachine, Canada; d. 1961, Curteis Point, Canada), née Muriel Wylie Liffiton, is the author of a B.C. classic. After her husband's death in 1926, Blanchet spent the next fifteen summers cruising the British Columbia coast with her five children in their twenty-five-foot boat, the *Caprice*. She condensed all their adventures and her own luminous world view into one book, *The Curve of Time*, published just before she died in 1961. It remains a perennial bestseller in the province.

Franz Boas (b. 1858, Minden, Germany; d. 1942, New York, U.S.) has been called the "father of American anthropology." Although he was born in Germany and based his career in New York, he did his most important fieldwork among the First Nations of British Columbia, where he made ten trips between 1886 and 1931. He was a voracious collector, but his detailed field observations, often obtained through local agents, remain priceless records of many traditional First Nations ceremonies.

Clint Burnham (b. 1962, Comox, Canada) is a Vancouver-based poet, short story writer and novelist. His books include *Airborne Photo* (short stories, 1999), *The Benjamin Sonnets* (poetry, 2009) and *Smoke Show* (2005), which he has described as a "stoner novel." He is also a freelance art critic. Burnham taught popular culture and literature at Emily Carr Institute of Art + Design from 1997 to 2006; he now teaches literature at Simon Fraser University.

Emily Carr (b. 1871, Victoria, Canada; d. 1945, Victoria, Canada) is considered the pre-eminent artist in the history of British Columbia painting; see Artist Biographies. Carr was also a powerful writer whose autobiographical works are Canadian classics. She did not publish her first book, *Klee Wyck*, a collection of stories about her visits to Native villages, until 1942, but it was an instant success and won a Governor General's Award. She wrote four other books, two published posthumously, including *Hundreds and Thousands* (1966), selections from her journals. Her writing is notable for its simple, unpretentious style and has been translated into more than twenty languages.

Wayson Choy (b. 1939, Vancouver, Canada) is a novelist and memoirist. He grew up in Vancouver's Chinatown, a world he evoked beautifully in his first and still most popular book, the novel *The Jade Peony* (1995). His other works include the novel *All That Matters* (2004) and two memoirs, *Paper Shadows: A Chinatown Childhood* (1999) and *Not Yet* (2009). Choy was named a member of the Order of Canada in 2005.

Douglas Coupland (b. 1961, CFB Baden-Söllingen, West Germany) is a novelist, essayist and visual artist. Born on a NATO base in West Germany, he grew up in West Vancouver. His first novel, *Generation X* (1991), was a huge success and gave its name to a generation of overeducated slackers searching for meaning in the coffee grinds of popular culture. He has since published eleven novels, including *Microserfs* (1995), *jPod* (2006) and *Generation A* (2009), and remains one of Canada's bestselling authors. Coupland has also written nonfiction, including *City of Glass: Douglas Coupland's Vancouver* (2000; updated 2009) and *Souvenir of Canada* (2002). His visual art involves photography, sculpture and installation and explores issues around mass production, the seductive nature of pop culture and his personal family history.

Leslie Drew (b. 1929, Nelson, Canada) is a newspaper reporter, editor and writer. Born and raised in the Kootenays, she was editor of the Prince Rupert *Daily News* and city editor of the Victoria *Daily Colonist*. In collaboration with Douglas Wilson, she wrote *Argillite: Art of the Haida* (1980), still an important reference work on the subject. In 1982 she also published *Haida: Their Art and Culture*.

Hubert Evans (b. 1892, Vankleek Hill, Canada; d. 1986, Sechelt, Canada) was a poet, novelist and non-fiction writer. Born in Ontario, he fought in the trenches in the First World War before moving to northern B.C. in 1919 to become a fisheries officer. By 1927 he was supporting his family by writing articles, short stories, radio plays and children's books. Among his many works is *Mist on the River* (1954), the first Canadian novel to portray Natives as real, complex characters. Margaret Laurence called him "the Elder of our Tribe," and one of the BC Book Prizes for non-fiction is named after him.

Joseph Ferone (b. 1942, Winnipeg, Canada) is a singer, trumpet player, poet, novelist and writer of musicals. A former longshoreman, tugboat hand, Arctic construction worker, merchant seaman and photojournalist, his best-known work is the novel *Boomboom* (1998), a witty murder mystery set on the Vancouver waterfront. He is presently gathering his 1960s street poems into a book.

Maurice Gibbons (b. 1931, Peterborough, Canada) is a retired university professor, writer, sculptor and consultant. He and his wife, Margot, were arrested at the Kennedy River Bridge on August 9, 1994; each received a fine of $1,250. "The Clayoquot Papers," his description of his part in the largest act of civil disobedience in Canadian history, was published in the 1997 anthology *Clayoquot and Dissent*.

Charlotte Gill (b. 1971, London, U.K.) writes both fiction and literary non-fiction. Born in England and brought up in the United States and Canada, she has an MFA in creative writing from the University of British Columbia. Her first novel, *Ladykiller* (2005), won the Danuta Gleed Literary Award and the Ethel Wilson Fiction Prize.

Terry Glavin (b. 1955, Chelmsford, U.K.) is an author and journalist. He has written for many publications, including the *Vancouver Sun*, the *Globe and Mail*, the *Georgia Straight* and the *Tyee*, on topics as diverse as global politics, natural history and anthropology. His eleven books include *Nemiah: The Unconquered Country* (1992), *The Last Great Sea* (2000) and *Waiting for the Macaws and Other Stories from the Age of Extinctions* (2006).

Guujaaw (b. 1953, Masset, Canada) is a Haida carver, writer, dancer, singer, politician and activist, of the G̱ak'yaals Kiigawaay clan, the Ravens of Skedans. He grew up on Haida Gwaii (the Queen Charlotte Islands) and was one of the leaders of the anti-logging battle that ended with the creation of the Gwaii Haanas National Park and Haida Heritage Site in 1993. He is also an accomplished carver who worked closely with Bill Reid on some of Reid's major works; his own poles stand as far afield as Indonesia and Peru. Guujaaw was elected president of the Haida Nation in 2000; in 2006, he received the Buffett Award for Indigenous Leadership.

Radclyffe Hall (b. 1880, Bournemouth, U.K.; d. 1943, London, U.K.) was an English poet and novelist, best known for her controversial lesbian novel *The Well of Loneliness* (1928). Although it is far from sexually explicit, the novel was the subject of a high-profile obscenity trial. The publicity generated huge sales, and the book soon became a classic; it is still probably the best-known lesbian work ever published.

Roy Kiyooka (b. 1926, Moose Jaw, Canada; d. 1994, Vancouver, Canada) was an artist of Japanese heritage; see Artist Biographies. He was also a hugely influential poet who was a driving force in the avant-garde Vancouver writing scene for three decades. His book *Pear Tree Pomes* was nominated for a 1987 Governor General's Award; his other publications include two posthumous works, *Pacific Windows: Collected Poems of Roy Kiyooka* (1997) and *Mothertalk* (1997), based on interviews with his mother, the daughter of a samurai who came to Canada in 1917.

'Laana awga Chief Sg̱iidagiids (b. 1881, Skidegate, Canada; d. 1970, Skidegate, Canada) was a Haida artist also known as Louis Collinson. He was of the Naa.yuu.aans Xaaydaagaay clan of the Skidegate Gitins. As a young man he was considered one of the best argillite sculptors alive, rivalled only by William Dixon and Charles Edenshaw.

Malcolm Lowry (b. 1909, Wallasey, U.K.; d. 1957, Ripe, U.K.) was a poet and novelist best known for *Under the Volcano* (1947), a heady tale of alcohol, infidelity and redemption that is widely considered to be one of the great novels of the twentieth century. Born in England, he lived in New York and Mexico (where *Volcano* is set) and did much of his writing in Dollarton, on Vancouver Harbour. His other works, most published posthumously, include *Hear Us O Lord from Heaven Thy Dwelling Place* (1961) and *October Ferry to Gabriola* (1970). *The Voyage That Never Ends* (2007) includes a selection of his best letters and poetry.

Daphne Marlatt (b. 1942, Melbourne, Australia) is a poet, novelist, teacher, editor and pioneering feminist. Born in Australia, she moved with her family to Malaysia before settling in Vancouver. Her many works include *Rings* (1971), a cycle of poems about pregnancy, birth and parenting; the novel *Ana Historic* (1988); and *Steveston* (1974; new edition 2001), a poetic portrait of a fishing village that was home to many Japanese Canadians who were interned during the Second World War. Marlatt was named a member of the Order of Canada in 2006.

David Pitt-Brooke (b. 1952, New Westminster, Canada) is a naturalist and writer who trained as a vet and has done wildlife research and worked as an environmental education officer for Parks Canada. His first book, *Chasing Clayoquot: A Wilderness Almanac* (2004), is an exploration of the extraordinary natural landscape around Clayoquot Sound, on the west coast of Vancouver Island. He has described it as "a political book about nature." He is currently working on a companion volume about B.C. grasslands, under the working title *Chasing Chilcotin*.

Bill Reid (b. 1920, Victoria, Canada; d. 1998, Vancouver, Canada) was a Haida artist who was pivotal in the rebirth of First Nations art on the Northwest Coast; see Artist Biographies. Until he received his first large carving commission, in 1958, Reid made his living as a radio announcer and scriptwriter, work that earned him the

Haida name Kihlguulins, "One with the Beautiful Voice." He continued to write into his later years; his best work can be found in the 2000 anthology *Solitary Raven: The Essential Writings of Bill Reid* (updated 2009).

Gregory Scofield (b. 1966, Maple Ridge, Canada) is a poet and playwright. A Métis of Cree, British, French and Jewish descent, he had a troubled childhood that included stays in several foster homes. His writing, including *The Gathering* (1993), winner of the Dorothy Livesay Poetry Prize, *Native Canadiana: Songs from the Urban Rez* (1996) and *I Knew Two Métis Women* (1999), explores his Native heritage and his experiences of sexual abuse, racism and poverty. His most recent collections are *Singing Home the Bones* (2005) and *Kipocihkân: Poems New and Selected* (2009).

Timothy Taylor (b. 1963, San Tome, Venezuela) is a novelist and short story writer. His highly praised first novel, *Stanley Park* (2001), is a father-son story about unsolved murders and high-end restaurants set in and around Vancouver's famous park; it was shortlisted for the Giller Prize and selected for the One Book, One Vancouver program of the Vancouver Public Library. It was followed by the story collection *Silent Cruise* (2002) and a second novel, *Story House* (2006), which revolves around an architect-designed house on Vancouver's Eastside.

Madeleine Thien (b. 1974, Vancouver, Canada) is a short story writer and novelist. She was born in Vancouver to parents of Malaysian-Chinese heritage. Her first book, the short story collection *Simple Recipes* (2001), won four awards in Canada and was a finalist for a regional Commonwealth Writers' Prize for Best First Book. Her first novel, *Certainty* (2006), an ambitious family story that moves between Vancouver, wartime Malaysia and Amsterdam, has been published in several countries.

Audrey Thomas (b. 1935, Binghamton, U.S.) is a prolific novelist and short story writer. Born in New York State, she moved to British Columbia in 1959 and now has homes in Victoria and on Galiano Island. She has won many awards over a long career and is the only writer to have won the Ethel Wilson Fiction Prize three times, for the novels *Intertidal Life* (1984), *Wild Blue Yonder* (1990) and *Coming Down from Wa* (1995). "I write primarily about women," she told an interviewer in 1986, "modern women with their particular dreams, delights, despairs... Madness, too, interests me, and the delicate balance between sanity and madness." Thomas was named an officer of the Order of Canada in 2008.

Michael Turner (b. 1962, Vancouver, Canada) is a musician and writer of poetry, fiction, screenplays, essays and opera librettos. His books include *Hard Core Logo* (1993), the story of a punk band, which was made into a highly praised 1996 film by Bruce MacDonald; *Kingsway* (1995), an exploration of one street in Vancouver; *The Pornographer's Poem* (1999), winner of the 2000 Ethel Wilson Fiction Prize; and the novel *8 × 10* (2009).

John Vaillant (b. 1962, Boston, U.S.) is the author of *The Golden Spruce: A True Story of Myth, Madness, and Greed* (2005), one of the most successful first books in B.C. history. Through the story of the renegade logger Grant Hadwin, Vaillant describes the larger history of the Haida nation and the B.C. forestry industry. The book won three major prizes—a Governor General's Award, the Pearson Writers' Trust Non-Fiction Prize and the Roderick Haig-Brown Regional Prize—and was a national bestseller. Vaillant is currently working on a book about Siberian tigers to be published in 2010.

Fred Wah (b. 1939, Swift Current, Canada) is a poet, novelist and scholar who was born in Saskatchewan and raised in the Kootenays. His complex heritage—Chinese and English on his father's side, Swedish on his mother's—plays an important role in his work. Wah has edited and published extensively in literary journals and small presses over four decades and has written seventeen volumes of poetry, including *Waiting for Saskatchewan* (1985), winner of a Governor General's Award. *Diamond Grill* (1996) is a "biotext," 132 short pieces about growing up in a small-town Chinese-Canadian café; *Faking It* (2000), a volume of criticism, won the Gabrielle Roy Prize for Writing on Canadian Literature.

Jeff Wall (b. 1946, Vancouver, Canada) is a Vancouver-based artist who has played a key role in establishing photography as a contemporary art form; see Artist Biographies. Wall has also produced critical texts that have helped define the pivotal role of photography in contemporary art. The most important, including the seminal 1995 essay "About Making Landscapes," were gathered in the 2007 Museum of Modern Art publication *Jeff Wall: Selected Essays and Interviews*.

David Watmough (b. 1926, London, U.K.) is a playwright, short story writer and novelist. Born in England, he worked as a reporter before immigrating in 1960 to Canada, eventually settling in Vancouver. His major work is a series of twelve novels and short story collections that tell the story of his alter ego, Davey Bryant, a gay man trying to make his way in a homophobic society. The series includes *Fury* (1984), *The Time of Kingfishers* (1994) and, most recently, *The Moor Is Dark beneath the Moon* (2002). In 2008 Watmough published *Myself through Others: Memoirs*.

Douglas Wilson (b. 1943, Queen Charlotte City, Canada) is a Haida artist and author. He is known for his carving in argillite and has also worked restoring older argillite works. In collaboration with Leslie Drew, he wrote *Argillite: Art of the Haida* (1980), still an important reference work on the subject.

Ethel Wilson (b. 1888, Port Elizabeth, South Africa; d. 1980, Vancouver, Canada) was a novelist and short story writer. After a childhood in South Africa and England, she was sent to Vancouver to live with her grandmother. She began writing in the 1920s and published her first novel, *Hetty Dorval*, in 1947. Her best known novel is *Swamp Angel* (1954), the story of a woman who escapes an unhappy marriage for a new life by a remote lake in the B.C. interior. The BC Book Prize for fiction is named in Wilson's honour.

Rita Wong (b. 1968, Calgary, Canada) has published two volumes of poetry, *monkeypuzzle* (1998) and *forage* (2007), the latter of which won the Dorothy Livesay Poetry Prize. She lives in Miami and in Vancouver, where she teaches critical and cultural studies at Emily Carr University of Art + Design.

Ronald Wright (b. 1948, London, U.K.) is the author of books of fiction, history, travel and political analysis. He studied archaeology at Cambridge University before moving to Canada, eventually settling on Salt Spring Island, B.C. *Stolen Continents: The "New World" through Indian Eyes* (1992) was a bestseller and won the Gordon Montador Award; his novel *A Scientific Romance* (1996) was highly acclaimed and won the David Higham Prize for Fiction. His most recent books are *A Short History of Progress*, based upon the 2004 Massey Lectures, and *What Is America?* (2008), subtitled *A Short History of the New World Order*.

SCOTT STEEDMAN

Acknowledgements

Bruce Grenville Acknowledgements

The *Visions of British Columbia* exhibition and parallel publication would not have been possible without the support and generosity of many individuals. I thank Kathleen Bartels, Director, for her drive to mount this ambitious exhibition presenting the art and artists of British Columbia to the world during a time when much attention will be focused on our city because of the Olympics. This exhibition was informed at the initial stages by many discussions with my colleagues Daina Augaitis, Chief Curator/Associate Director, Ian Thom, Senior Curator, and Grant Arnold, Audain Curator of British Columbia Art; I am grateful for their invaluable advice and wise suggestions. Emmy Lee, Assistant Curator, played a critical role in the realization of this exhibition and publication. Her thoughtful contributions to the selection of the art and artists, her knowledge of the collection and her unerring ability to bring order to chaos made her an invaluable colleague in this project. I am grateful for her commitment and contribution.

We are very appreciative of the private collectors and regional museums who parted with their artworks for months; in many cases, these loaned works helped fill critical gaps in our collection so that we could present a richer story of the culture of the province.

The staff of the Vancouver Art Gallery were instrumental in bringing both the publication and the exhibition to fruition, and neither aspect of this project would have been possible without their expertise and dedication. The exhibition drew heavily on the Gallery's permanent collection, which has been conscientiously and meticulously cared for over the years by the outstanding staff of our Museum Services department. Trevor Mills and Rachel Topham in Photography have beautifully captured the great majority of the works reproduced here. I also want to note the contribution of my curatorial department colleagues Karen Love and Suzanne Hepburn. Peter Macnair, Jay Stewart and Martha Black provided invaluable advice and I am grateful for their willingness to share their unique knowledge.

This publication was a collaborative effort between the Vancouver Art Gallery and Douglas & McIntyre; Chris Labonté and Scott McIntyre at D&M supported this atypical publication from the start and were willing to adopt its experimental structure. Peter Cocking created the contemporary design, suggested creative solutions to the many queries and kindly adapted to our many edits; we are thankful for his creativity and diligence. Scott Steedman, co-editor of this publication, was an inspired colleague who managed to find engaging and poignant texts to accompany each of the artworks. The texts he has presented subtly complicate the images and vice versa.

Finally, this project allowed me to spend considerable time with the work of artists and authors of British Columbia—and to them I am especially grateful. Their work gives shape to the culture of this place and is an inspiration to people here and beyond.

Scott Steedman Acknowledgements

This book grew out of a series of discussions about B.C. art and writing with Bruce Grenville, and I would like to thank him wholeheartedly for taking a risk and asking me to join him in editing it. Thanks also to Bruce's colleagues at the Vancouver Art Gallery, including Karen Love, Daina Augaitis, Suzanne Hepburn and particularly Emmy Lee, who was tireless in her enthusiasm. I must also acknowledge the five men and one woman of the round table—Clint Burnham, Douglas Coupland, Peter Culley, Lee Henderson, Michael Nicoll Yahgulanaas and Deborah Campbell—who spent three hours filling an old courtroom with their deep knowledge of B.C. writing; your comments were invaluable, and I wish we could have included even 10 per cent of your suggestions, especially the one about the sacred-cow meter. Thanks to Peter Macnair, for his incomparable knowledge of Kwakwaka'wakw oral traditions. And finally, thanks to Leilah, for keeping me on my toes, and to Sami, for smiling through it all.

The Vancouver Art Gallery is tremendously grateful for generous funding of *Visions of British Columbia: A Landscape Manual* from Presenting Sponsor, Raymond James Ltd., and Supporting Sponsor, Vancouver Airport Authority. This exhibition is also made possible through major support from the Province of British Columbia.

facing: **Fred Herzog** | Howe and Nelson, 1960 (detail)

Jeff Wall | Logs, 2002

Lenders

Institutional Lenders

National Archives of Canada

Royal British Columbia Museum

Museum of Vancouver

Private Lenders

David Allison and Chris Nicholson

Family von Brauckmann

Donald Young Gallery

Tim Gardner

Chris Gergley

Rodney Graham

Catriona Jeffries, Vancouver

Iqbal and Yasmin Kassam

Zoe Lasham and Reid Shier

Scott McFarland

Michael O'Brian

Monte Clark Gallery

Susan Point

Private Collection, Nanaimo

Private Collection, San Jose

Private Collection, Vancouver

303 Gallery, New York

Union Gallery, London

Michael Nicoll Yahgulanaas

Jin-me Yoon

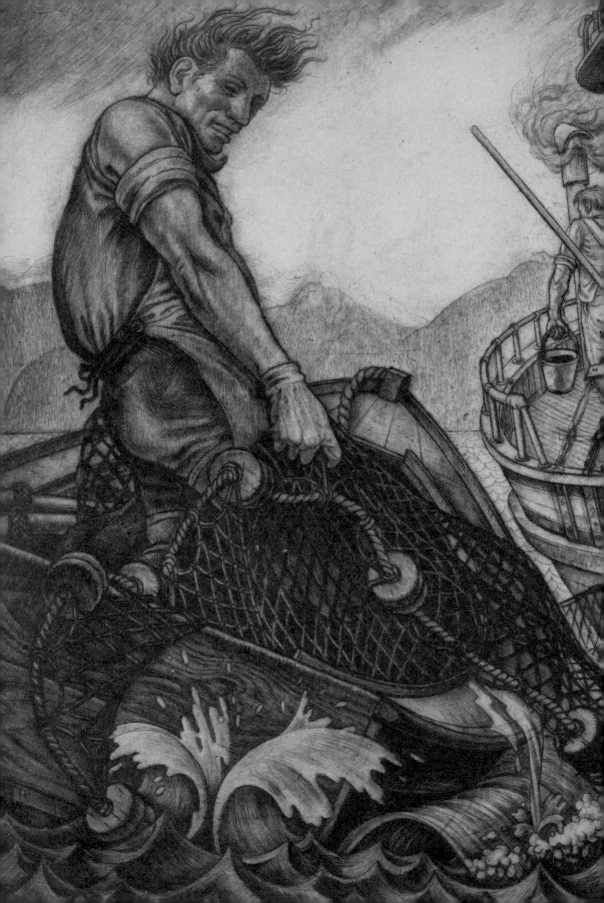

09 10 11 12 13 5 4 3 2 1

Douglas & McIntyre Vancouver Art Gallery
An imprint of D&M Publishers Inc. 750 Hornby Street
2323 Quebec Street, Suite 201 Vancouver BC Canada V6Z 2H7
Vancouver BC Canada V5T 4S7 www.vanartgallery.bc.ca
www.douglas-mcintyre.com

Library and Archives Canada Cataloguing in Publication
Visions of British Columbia: a landscape manual / edited by Bruce Grenville, Scott Steedman.
Co-published by the Vancouver Art Gallery. Published in conjunction with an exhibition
held at the Vancouver Art Gallery, Vancouver, B.C., from Jan. 23–April 18, 2010.

ISBN 978-1-55365-500-8

1. British Columbia—In art—Exhibitions. 2. Art, Canadian—British Columbia—
20th century—Exhibitions. 3. Art, Canadian—British Columbia—21st century—Exhibitions.
4. Canadian literature (English)—British Columbia. 5. Canadian literature (English)—
20th century. 6. Canadian literature (English)—21st century. 7. British Columbia—
Literary collections. I. Grenville, Bruce II. Steedman, Scott III. Vancouver Art Gallery
N6546.B7V584 2010 709.711'07471133 C2009-905084-6

Cover and interior design by Peter Cocking
Publication coordination by Emmy Lee, Vancouver Art Gallery
Digital image preparation by Trevor Mills and Rachel Topham, Vancouver Art Gallery
Printed and bound in Canada by Friesens
Printed on paper that comes from sustainable forests
managed under the Forest Stewardship Council
Distributed in the U.S. by Publishers Group West

FSC Mixed Sources
Cert no. SW-COC-001271
© 1996 FSC

D&M Publishers Inc. gratefully acknowledges the financial support of the Canada Council for
the Arts, the British Columbia Arts Council, the Province of British Columbia through the Book
Publishing Tax Credit, and the Government of Canada through the Book Publishing Industry
Development Program (BPIDP) for our publishing activities.

The Vancouver Art Gallery is a not-for-profit organization supported by its members; individual
donors; corporate funders; foundations; the City of Vancouver; the Province of British Columbia
through the British Columbia Arts Council and Gaming Revenues; the Canada Council for the Arts;
and the Government of Canada through the Department of Canadian Heritage.

Presenting Sponsor With major support provided by

RAYMOND JAMES
 BRITISH
 COLUMBIA
 CANADA

Supporting Sponsor